Against Cultural Property

DUCKWORTH DEBATES IN ARCHAEOLOGY
Series editor: Richard Hodges

Also available

Archaeology and Text
John Moreland

Beyond Celts, Germans and Scythians
Peter S. Wells

Combat Archaeology
John Schofield

Debating the Archaeological Heritage
Robin Skeates

Loot, Legitimacy and Ownership
Colin Renfrew

Origins of the English
Catherine Hills

The Roman Countryside
Stephen L. Dyson

Shipwreck Archaeology of the Holy Land
Sean A. Kingsley

Social Evolution
Mark Pluciennik

State Formation in Early China
Li Liu & Xingcan Chen

Towns and Trade in the Age of Charlemagne
Richard Hodges

Villa to Village
Riccardo Francovich & Richard Hodges

Against Cultural Property

Property

ARCHAEOLOGY, HERITAGE
AND OWNERSHIP

John Carman

Duckworth

First published in 2005 by
Gerald Duckworth & Co. Ltd.
90-93 Cowcross Street
London EC1M 6BF
Tel: 020 7490 7300
Fax: 020 7490 0080
inquiries@duckworth-publishers.co.uk
www.ducknet.co.uk

© 2005 by John Carman

A catalogue record for this book is available
from the British Library

ISBN 0 7156 3402 X

Typeset by Ray Davies
Printed and bound in Great Britain by
CPI Bath

Contents

To Patricia, at last

Preface

This book begins where my last book in the field of archaeological heritage management ended. That book – an introductory text for students of archaeological heritage management (Carman 2002) – was written with two fundamental purposes: to provide what was currently lacking to students in the field, in the form of an introductory outline to AHM internationally; and to encourage the take-up of research projects in the field. To the latter end, the final chapter suggested that a key area for future research lay in looking at issues of ownership as they affect the management of the archaeological heritage, and especially how ideas about ownership are involved in our understanding of that heritage and its treatment. This book attempts to take these ideas a little further by examining the implications for archaeological remains of the main types of property relation as identified by lawyers and economists.

The idea for this book goes back a number of years and has seen some transformation over that time. I originally came to archaeology out of commercial administration, a field in which I worked in areas such as finance and law. My first research in archaeology drew heavily on this background and resulted in my first published book, which examined the way law 'works' on archaeological remains in England (Carman 1996b). It was my plan to follow up this work by an examination of particular categories of ancient remains and the ways in which they were managed, and to do this through the perspective of the various notions of property applied to them in particular management

regimes. As envisaged, it would have been something of a *magnum opus* and a far longer (and much less approachable) text than I hope this is. In the end, it turned out to be a project somewhat beyond my capacity. Much of the text I provisionally wrote for that work was subsequently included in the student book, leaving me with unconnected passages which on their own made little sense. Having, however, publicly declared my interest in property notions as applied to archaeological remains, it seemed incumbent upon me to follow them up. Hence this book.

This book addresses areas generally left out of archaeological discourse, and yet crucial in any consideration of AHM practice. It begins from the premise – considered in more detail and more fully justified in Chapters 1-3 – that the discussion of ownership in AHM, such as it is, is severely truncated. It goes on to consider the implications for the treatment of archaeological remains of the main types of property identified in the two fields which have most to say about property relations: economics and law. It is difficult to argue against the notion that one way or another most if not all civil legal disputes turn upon issues of ownership: this is primarily what civil law is concerned with, and a significant portion of criminal law as well. And economists assess the efficiency of resource allocation – their own major concern – very often in terms of the distribution of ownership and use rights; and in doing so they usually assume the rightness of one or another set of property relations. Issues of property – that is, ownership and use rights – are thus central to these fields and it is therefore appropriate that they are the fields in which most writing about property is to be found.

Chapter 2 outlines the attributes of the four types of property generally recognised in economics and law – private, state, communal, and open-access – and also addresses some of the relevant critiques of property notions from political and eco-

nomic theory. In general, communal and open-access property regimes are regarded as problematic in economics and law: proposed solutions usually concern the allocation of specific exclusive property rights to particular persons or institutions. However, as Chapter 4 will explore, the attribution of property characteristics to the archaeological heritage (indeed any heritage) creates other problems which are difficult to resolve in this way. Accordingly, Chapters 5 and 6 will expressly consider the relevance of ideas about communal ownership and open-access to the heritage. Chapter 7 will provide a summary and some ideas for the future.

Although it draws heavily upon ideas from economics and law, this is not a book about economics or law, nor a book for economists or lawyers: it will tell the latter little they may not already know. This book is instead about archaeology, and specifically the material which archaeologists study and – crucially – manage. Archaeology does not exist in a vacuum, and notions from other fields – from law, from finance, from economics, from environmental science, from management – are already deeply implicated in the management of the archaeological heritage. It is a pervasive myth among archaeologists – and especially those charged with managing archaeological resources – that the ideas and concepts they work with derive purely from a pristine archaeology. It is not so: this book aims to outline the importance of recognising the origins of some of the ideas we use so readily, and the dangers and problems involved in their uninstructed and wholesale adoption.

Acknowledgements

As always, although this book is notionally the product of one person's work, who accepts full responsibility for any errors of fact and interpretation together with any infelicities of style, it has also seen the contribution of others to its development. I thank first Deborah Blake and Richard Hodges, respectively Editorial Director and Series Editor at Duckworth, for their keen and speedy acceptance of this work for publication and their patience in awaiting its arrival, together with all the help they have been in advising about content and style.

Discussion of issues relevant to the content of the book have been held with a number of friends, colleagues and students, especially including Dr Mary-Catherine Garden of Glasgow Caledonian University, Dr Darrin Lee Long, Dr Carol McDavid of the University of Houston in Texas, and Morag Kersel of the Department of Archaeology at the University of Cambridge. I am also extremely grateful to Dr Neil Brodie of the Illicit Antiquities Centre at the McDonald Institute for Archaeological Research in Cambridge for specific advice on illicit antiquities.

Last but not least, as reflected in the dedication of this book, and as always, deepest gratitude goes to my wife Patricia for all her support over the years.

1

Illicit antiquities: where categories, value and property meet in archaeology

This is not a book about illicit antiquities, nor does it offer any specific remedies to that particular and widespread problem: for this see other texts (such as, in this series, Renfrew 2000; see also Brodie et al. 2001; Brodie and Tubb 2002; O'Keefe and Prott 1997; Messenger 1999). In considering archaeological remains as property, however, the problem of illicit antiquities represents a good place to start since so many of the relevant issues combine in this one area. These concern especially the ways in which we conceive, give value to and treat those objects that come to us from the past.

Issues of categorisation

In archaeology in general, objects of concern are not only those that can be carried around and come to us complete. Instead, archaeologists more typically engage with fragmentary remains, monumental structures that are fixed in place, material scattered across space, and indeed the very landscapes in which such objects are found. Furthermore, the material that is the subject of archaeological study can cover objects with entirely different kinds of origin. It can be either:

- objects or the remains of objects that were deliberately made,

such as ritual landscape monuments, buildings, shaped land, artworks, or made utensils; or
- the accidental product of other human activities which nevertheless leave their traces in the world, such as field systems, eroded soils, lost woodlands, and drained wetlands.

From all these things, only those moveable objects which are complete (or nearly so) and can be classed as 'art' can find their way into the category of 'illicit antiquity': fixed monuments, ruined buildings, landscape features, the majority of utilitarian objects, and fragments of former objects are generally denied this particular status.

Those objects that become illicit antiquities therefore form one relatively small set of all the things with which archaeologists are concerned, and yet the global scale of the problem reflects the wide extent of archaeological concern. Although the true extent of the global trade in illicit antiquities is unknown, some statistics illustrate its scale (from Brodie, Doole and Watson 2000):

Italy, 1940-1962	400 out of 550 Etruscan graves looted in one region alone
Iraq, 1991	3,000 items looted
Turkey, 1993-1995	17,500 incidents of stolen antiquities
Bulgaria, 1992	5,000 icons stolen
Nigeria, 1990s	400 objects stolen from museums
Mali	45% of sites looted
Guatemala	estimated 1,000 pots (worth around $10 million in all) smuggled out each month

Among all these objects lost to academic study are two distinct kinds of 'illicit' object, defined in terms of the kind of illicitness to which hey have been subjected.

1. Illicit antiquities

- First are items that have been illegally removed or stolen. This includes items illegally taken from private and museum collections, from churches and other repositories. It also includes those objects removed illegally from archaeological contexts. These include those excavated from sites in territories where all archaeological remains belong under law to the state; or where this does not apply, from sites which are subject to legal controls and protection; or to particular materials which are the property of the state regardless of context of deposition. Any such object may subsequently (or consequently) find its way onto the market for such items. Others may simply pass to other (usually private) collections by clandestine means.
- Second, appear those items that although legally owned by someone other than the State, are subject to restrictions on movement and especially export to another country. If they are quite legally sold to another owner and then transferred from the country of origin without appropriate permissions, these too are deemed illicit even though not stolen.

Some objects will of course fall into both categories. It is not uncommon for illegally acquired objects to be then also illegally transferred across territorial boundaries. It is also not uncommon for different kinds of illicit antiquity to be distinguished. Those stolen from institutions and collections are generally recognised as illicit by all concerned, even if – as in some cases – they are happy to pass them on to new owners. Objects removed from archaeological contexts may not be regarded as quite so illicit: arguments may turn upon the appropriateness of state ownership for ancient remains, the denial of access to the general public involved, the special status in dealing with the past granted to professional archaeologists, and so on (see e.g. Skeates 2001). Those objects legally owned but illegally moved may not be seen as 'illicit' in any sense: arguments will

turn upon the rights of private property, limitations on individual freedom, and again the special status awarded to scholars. In defining and ascribing illicitness, differences emerge between the different institutions involved.

The key issue for archaeology is always loss of information about the past. As Renfrew, in particular, argues 'collectors are the real looters' (Renfrew 1993; 1995; 2000). For him and others, the removal of any ancient object from its context of deposition without proper recording constitutes looting. If there were no people desirous of owning such objects, they argue, then there would be no market for them and no incentive for anyone other than a scholar armed with the techniques of archaeology to investigate sites. But because there is such a market, there are those who seek to feed it by providing objects retrieved from archaeological sites. They do so purely to gain access to objects for sale, disregarding other material that may be present, disturbing the soil, destroying stratigraphy, and eradicating buried features. It is irrelevant from such a point of view whether this activity is carried out in Italy by professional *tomboroli*, by amateur treasure-hunters in the UK or by local community pot-hunters in Bolivia. It is equally irrelevant whether the material retrieved belongs to the state as in Italy, to the landowner as in the UK, or to a commune as in Bolivia. All are equally guilty of damage to the archaeological record.

The logic of such a position may appear to demand that those items transferred from collection to collection – whether legally or illegally – are considered as less important than those removed from an archaeological deposit. What is at stake here, though, is the loss of information about the object that may not travel with it. All objects in the market have a 'provenance' – a history of discovery and subsequent treatment. Those objects that are stolen or otherwise illicitly transferred to the market – such as following on illegal export – will emerge with no clear provenance, or an incomplete or entirely false one. With no

certain history, relating the object to its origin and the products of research on it will be impossible. The loss to scholarship in both situations is thus significant. What is of no consideration is the financial value of an object.

By contrast, the key issues for lawyers concerned with cultural property and with dealers in antiquities are those of ownership and value. It is probably fair to say they see antiquities not (or not only) as objects containing information, but more particularly as objects of aesthetic beauty, as 'art' rather than 'archaeology'. Issues of context and to some extent provenance are therefore of less importance. What does matter is the route by which the object found its way into a collection or onto the market, and illicitness is measured in terms of the legal status of an object. An item that has been stolen from its legitimate owner – either by removal from that owner's custody or, in a country where all archaeological remains are owned by the state, by removal from the context of deposition – will be classed as illicit. An object legally acquired but illegally transferred into another jurisdiction may not be classed as quite so illicit, especially where the new jurisdiction takes no notice of such illicit transfers. An object apparently legally acquired will always be regarded as licit, regardless of the specific circumstances.

The provenance of an object here takes on a very specific significance: the primary concern will be the object's history after its discovery and retrieval, rather than its context of deposition. So long as the provenance does not indicate any failure of title to the object – in other words, that the assumed owner is the owner and has full rights of ownership – then the object will be regarded as licit. This of course encourages the falsification of provenances and the passing-off of objects as something other than they truly are. Recently-retrieved objects may be described as coming from a region other than that where they were found, or may be ascribed to a much earlier

collection of similar objects. Objects stolen from their context of deposition may enter the market as replicas of themselves, to be 'recognised' as genuine later. It may serve the interests of dealers in certain types of object to flood the market with fakes and replicas so that illicit originals may be 'lost' among the crowd and thereby gain a false provenance. This provenance has nothing to do with archaeological or historic value, nor even with aesthetic quality, but does affect the object's suitability for trade and therefore its financial value. And it is this which is ultimately the crucial factor for dealers and collectors, who see antiquities primarily as commodities in the marketplace.

Issues of value

A more general discussion of the kinds of value that can be – and are – placed on archaeological material will be reserved for Chapter 3. Here the discussion will be limited to the idea of such objects as commodities, and – since the focus of this chapter is upon portable antiquities – especially how this relates to and contrasts with their place in the public institution of the museum. It is however clear that various values can be placed upon ancient material – including, but not limited to, the financial, the historical and archaeological, and the aesthetic. None of these values is measured in the same terms and none is exclusive: any object can be at once of financial, historical and artistic value, or of none of these.

Marx defined the form of wealth produced under capitalism as 'an immense accumulation of commodities' (Marx 1949: 1) and his critical analysis of capitalist production thus begins with an attempt to demystify the commodity. This is an object that has a use-value dependent upon the amount of labour 'embodied or materialised in it' (Marx 1949: 5); the commodity also acquires 'exchange value' in the process of exchange for something else, a process which serves to mask the initial input

of human labour in the creation of the object. The net result is the alienation of the object from its producer and of the value thus created, and accordingly the creation of a space in which producers can be exploited. A 'commodity appears, at first sight, a very trivial thing, and easily understood. Its analysis [by Marx] shows that it is, in reality, a very queer thing, abounding in metaphysical subtleties and theological niceties' (Marx 1949: 41).

Appadurai (1986: 9) goes further to define the commodity as '*any thing intended for exchange*' (emphasis in original), and almost any object can therefore become a commodity when it is so marked culturally (Kopytoff 1986: 64). Baudrillard goes further again, outlining the expansion of the realm of exchange value to include everything previously considered inalienable – 'virtue, love, knowledge, consciousness' (Baudrillard 1975: 119) – a process which Marx could not have seen from his vantage point in the nineteenth century (Baudrillard 1975: 120). In a discussion echoing Foucault's (1977) notion of the 'disciplinary society' Baudrillard explains late twentieth-century capitalism in terms of 'the passage from the form-commodity to [that of] the form-sign, from the abstraction of the exchange of material products under the law of general equivalence to the operationalisation of all exchanges under the law of the code It is a matter of the passage of all values to exchange-sign value under ... a structure of control and power much more subtle and more totalitarian than that of [simple] exploitation' (Baudrillard 1975: 120-1). We are, he argues, today in an epoch where the emphasis is placed upon consumption of commodities rather than their production, so the contemporary 'critique of culture, of consumption, of information, of ideology ... made in terms of 'capitalist prostitution' [that is, in terms of commodities, exploitation, profit, money and surplus value *per* Marx] ... is [now] illogical if the [focus is placed upon] *the commodity*' (Baudrillard 1975: 120-1, emphasis in original).

Despite attempts to distinguish 'museum' value from commercial value as part of the construction of a viable theory for heritage management (Carman 1995a; Carman 1996b: 64-5), the practical effect of the English law of Treasure was always to deal with objects as if the precious metal of which they were made was the important thing about them (Carman 1996b: 55-7). Similarly, Thoden van Velzen's (1996) discussion of Tuscan tomb-robbers' ideology emphasises the importance to these *tomboroli* of the prospect of financial gain from their looting of ancient sites. The auction of antiquities serves to give them a 'rebirth' and 'new values, new owners and often new definitions' in a 'search for legitimacy' (Smith 1989: 79); in this way, the art gallery acts as one medium by which a sense of the past is constructed (Popular Memory Group 1982). The art and antiquity auction itself is a 'tournament of value' (Appadurai 1986: 21) not organised along strictly economic lines but concerned with questions of prestige and status (Baudrillard 1981: 117); this was certainly evident in the case of the so-called 'Sevso Treasure' (Carman 1990: 203-5).

It is conventional to contrast the commercial market with the museum and to some extent these represent the different realms of public (museum) and private (market) activity. Nicklin (1990: 300), however, shows the manner in which the treatment as commodities of ancestor figures from Oron, Nigeria may nevertheless lead them to a place in the collection of a (public) museum: either through purchase in the international market, or by virtue of having been looted during the Nigerian civil war and subsequent placement in the National Museum. This example of a single class of object demonstrates the deep implication of the museum as an institution in the market which is supposed to operate on very different principles. Johnson and Thomas (1991: 6) demonstrate that museums can be treated and assessed in the same manner as any other economic organisation despite their overtly non-market pur-

pose as 'an institution which collects, documents, preserves, exhibits and interprets material evidence and associated information for the public benefit'. Here the public status of the museum is affirmed and is widely shared along with a belief in the museum's relation to the academic realm: 'Archaeology rests very comfortably in the museum context It is a measure of the direct social relevance of archaeology that the repositories for its raw material ... should be public institutions whose principle functions are the provision of a cultural service' (Crowther 1989: 42).

There is a hint of the suggestion that museums are not entirely academic institutions, however, in the focus on 'ethics' in the literature. Ashley-Smith (n.d.: 1), for instance, is concerned with issues of the relative 'rights' of 'practitioners' and owners and their resolution by the adoption of codes of practice. Similarly Warren (1989) addresses the resolution of central 'cultural property issues' – those of 'restitution', of 'restriction' (on export and import) and of 'rights', especially of ownership. This focus on ethics represents the manner in which the 'European world of capitalist supply and demand [overcomes the problem of finding] itself unable to bring its principle intellectual material within its [commodity] system' (Pearce 1995: 378). Museums represent 'material heaven' above and beyond the mundane market (Pearce 1995: 392). The role of the museum is therefore the authentification of the system of which it is inevitably a part; the museum's role is to act as 'the still small voice against which truth can be verified and judged' (Pearce 1995: 392). The role of the market in the system is that of 'a necessary mechanism which enables us to keep in touch with, and give expression to, our own abiding and changing senses of what things we believe to be important in one significant aspect of our material lives' (Pearce 1995: 381). By this means the system as a whole becomes a dynamic one in which 'elements circulate in different ways to create collections which them-

selves produce value changes' in the system (Pearce 1995: 393). The museum is thus necessarily implicated in the market for those categories of objects that are considered suitable for inclusion in the museum collection, and this requires that such objects be seen first as forms of property.

Issues of property

Attempts to ameliorate the effect of the trade in illicitly-acquired antiquities take various forms. One approach consists in carefully distinguishing the trade *per se* from a specifically *illicit* one by a strict reading of international laws (Cook 1991: 536). Another recommends a market-price distinction between fully documented and unprovenanced items, with the latter priced at a significantly lower level (Cannon-Brookes 1994: 350). A third urges the redirection of museum and collectors' funds towards 'long-term loans of objects, to the care and study of original material or the conservation of monuments *in situ*, to help with the protection of archaeologically and environmentally sensitive landscapes in economically disadvantaged countries, to the training of local academic and conservation experts' (Isler-Kerényi 1994: 352). While, if workable, none of these initiatives should be dismissed – and Renfrew also recommends a strict application of legal regulation by museums and auction houses (Renfrew 1995: 8-9) – the problem is less one of law than of differing ideologies.

The archaeological response to the threat of the trade in antiquities is to attempt to declare such a trade illicit in and of itself. The aim overall is to place a limit on the capacity for private collections of antiquities by gaining widespread recognition of the tenet that 'collectors are the real looters' (Renfrew 1993). This involves first demanding the prosecution of those who trade in explicitly illicit antiquities, in particular those that have been illegally acquired by theft, by looting and by

24

illegal excavation. Where it is not possible to apply the more usual penalties for criminal behaviour, such as where it is an institution or organisation that is at fault rather than specific individuals, the call is for financial penalties and restrictions upon their right to trade. Although in many countries law bars excavation by non-professionals, this is not a universal pro-scription; accordingly, the call is for a specific universal and enforceable ban on treasure hunting and the trade in antiq-uities. Where any of these cannot be imposed, a closer reliance may be placed upon professional and institutional Codes of Practice. These may require museums to have no dealings with private collectors or the trade, dealers to take effective precau-tions against the entry of illicit antiquities into the market, and collectors to limit the content and extent of their collections. These measures are grounded in the belief that private collect-ing – both legal and illicit – encourages looting for financial gain, resulting in the loss to all human beings of the valuable archaeological data which is their heritage.

The solutions offered seek to end or at least to limit opportu-nities for private ownership of archaeological remains. Instead, ownership – or at least the rights that are usually attached to ownership – will pass to the state or some other institution serving the public interest in the past. In practice, this is most likely to mean placing the responsibility upon museums and academic institutions who are held to act for the general wel-fare and – particularly – outside the realm of the economic market. It is a corollary of such arrangements that material held by the state or in museums for and on behalf of the public may not be traded, nor passed to another owner unless they too are similarly barred from operating in the market. The extent to which such treatment may represent the removal of these items from the realm of ownership will be considered further in Chapter 4, but here it will suffice to point out that the specifics

of such proposals explicitly involve the transfer of ownership rights rather than their removal.

Taking a different approach to the trade, the American lawyer John Merryman (1989) has put an analysis of the types of value applicable to antiquities to effective use in his campaign for a 'licit' trade in cultural objects. He recognises the change of context involved in bringing an ancient object into the present, since 'much of what we value today as cultural property originally had a religious function' (Merryman 1989: 351). He lists the 'utility' of such objects as those of learning about the past, giving pleasure and enriching life, as a form of (economic/financial) wealth, and as tourist assets (also related to money) (Merryman 1989: 353-5). He lists the components of effective cultural property policies to be: 'preservation', although he believes this is sometimes taken too far (Merryman 1989: 355-8); 'truth' in the form of ensuring the authenticity of the object (Merryman 1989: 359-60); ensuring 'access' to the object by scholars and others (Merryman 1989: 360); and 'cultural nationalism' which 'has a disproportionate influence in cultural policy' (Merryman 1989: 361-3). Against the current cultural property regime – which he argues to be 'nationalist [and] retensionist' (Merryman 1994: 2) – he recommends the establishment of a specifically licit trade in antiquities, governed by international law (Merryman 1994: 34-5). This trade would be in specifically 'moveable' objects, defined as those which can be moved abroad without 'danger' to themselves; and in 'redundant' archaeological objects, which do not require to be held in a museum for the purposes of study (Merryman 1994: 36). A trade in objects legitimately acquired but illegally exported would also be allowed, since illegal exportation is distinguishable from illegal acquisition and a matter for national law only (Merryman 1994: 31). The structure of the trade would allow for both barter and a cash market (Merryman 1994: 38-42) on the grounds that 'market price and value ... are

not identical notions But market price is an *indicator* of value, often the only or the best available indicator [The licit international] market provides a medium for a substantial flow of efficient transactions' (Merryman 1994: 41).

Merryman's argument is thus, at root, economic and legalistic. He suggests that because a trade is physically possible and allowed by the rules, it should come into being. He counters the charge of 'commodification' on the grounds that the argument 'that the work of art itself is somehow reduced or sullied by being bought and sold... does not bear scrutiny' (Merryman 1994: 54). He adds 'there is a close relation between art world consensus about artistic value and market value' and these tend to change together (Merryman 1994: 55). He condemns the commodification objection to the licit market as therefore 'an effete prejudice' (Merryman 1994: 55). He suggests that such a trade will have the desired effect of reducing 'clandestine archaeology' by effectively reducing the demand for illicitly-produced items by feeding a legitimate market (Merryman 1994: 42-52). At the same time it will encourage a shift in the politics of the trade from a politics of nationalism to one of internationalism, and a shift of resources from rich (buyer) nations to poor (supplier) nations (Merryman 1994: 56-63). In his scheme, the licit trade in antiquities will thus promote the values of the object itself and of its traffic across the globe over those of the individual nation state from which it derives (Merryman 1994: 64). He assumes throughout that any object brought to the market will find a buyer. Also, in taking an economic line of argument, he fails to consider the effect on demand of an increase in supply: these objects are not 'necessities' on which expenditure can be expected to remain constant (Douglas and Isherwood 1979: 97-8) and so the market will respond differently.

In attempting to resolve the problem of the illicit trade in antiquities and the 'retensionist' policies of states, Merryman

does not challenge the basis on which these phenomena operate but instead responds in kind: to a problem of ownership he responds with an increase of ownership opportunities. By the same token, Renfrew responds to a problem of ownership by placing ownership in the hands of a single authorised entity. The thesis of this book is that it is the notion of ownership itself which is the problem in our treatment of ancient remains.

2

Property

The issue of property relations has recently re-emerged as a topic of concern within the field of anthropology (see for instance Harrison 1992; Hann 1998; Brown 2003; Verdery and Humphrey 2004), and some of this literature will be addressed in subsequent chapters. Here, however, it is worthwhile noting that much of the discussion in anthropology takes the form of critique of an exclusive private property, although there are in fact four main types of property recognised by economists and lawyers. These will form the topic of this chapter.

The four types of property most usually recognised are shown in Table 2.1. In terms of the kinds of rights attached to each, *private* property provides exclusive rights; *common* property provides shared rights; under *state* property all rights are abrogated to national government; while *open access* provides very poorly defined rights. Concomitant duties consist only of restraints (cf. Cole 2002: 9; Young 1992: 94-5). In general there is no fundamental distinction between state ownership and private ownership: the state as a single corporate entity has as full and complete ownership rights as any individual, with full right of exclusion of use or access; the difference lies in who makes the decisions, the corporate state or a private individual. By contrast, common property is held by a group of individuals who each have certain defined rights of use or access but who are also required to meet certain restrictions on such use or access. There are no such defined rights or restrictions in

Table 2.1. Types of property (after Cole 2002: 9)

Property type	Associated rights	Associated duties
State property	Of agencies, to enforce rules about access & use	Of individuals, to observe rules set by agencies
Private property	Of owner, to undertake socially acceptable uses	Of non-owners, to refrain from interference with rights of owner
Common property	Of owners, to exclude non-owners from use and to undertake agreed uses	Of non-owners, to abide by exclusion Of owners, to refrain from interference with rights of other owners
Open access (non-property)	Of individuals, to use for any purpose	None

relation to open access property, which is open to all to use as they will (Table 2.1).

In practice, an absolute right of private property is rarely encountered. Although there may be no legal restraints on private owners in a particular regime, their actions may well be effectively constrained by custom or expectation. In the case of 'environmental goods' – such as cultural property – where a 'public interest' may apply, a system of state regulation usually operates alongside private ownership, providing some degree of control on private owners. These 'mixed' property regimes (Cole 2002: 45-84) involve the sharing of ownership rights, but not

equally as in the case of communal property. Instead, certain rights of ownership will devolve on the private owner, while others will be reserved for the state. This is the situation in respect of scheduled and guardianship monuments in Great Britain, for example: legal ownership of the site or monument stays with the landowner, but other rights – such as the right to alter or destroy the monument or to use it for educational or tourist use – are held by the state (Carman 1996: 216-18). In practice in such arrangements, the state will usually desist from actions resulting in damage, but by reserving such rights to itself it places a limit on the actions of the private landowner.

Moreover, as Cole (2002: 13) points out, there 'is no such thing as a pure or unadulterated public or private property system' and his own typology (Cole 2002: 10) has them overlapping in various ways. Here, *non-property* or open access stands apart from all other regimes, and is neither affected by nor affects them. *Public* (for which read State) property also includes ownership by localities, tribes and communes, which are more properly types of common ownership. Other forms of *common* or shared ownership – co-tenancy agreements, together with corporate, family and partnership arrangements – are also forms of *private* property since they exclude public bodies. Exclusive individual ownership is also a form of private property, however. Joining them all are systems of mixed property, such as land trusts or conservation arrangements where public bodies retain some rights while others are exercised by a private owner, or tradeable pollution rights, which are privately owned and capable of transfer by sale but overseen and regulated by the State. Later, I shall readdress aspects of this list, in particular to challenge the idea that institutional ownership (included here under the 'corporate' label) is really a form of common property; but this brief review of Cole's scheme serves usefully to emphasise the complexity of property relations in the real world.

Arguments for property

There are many arguments for allowing and even requiring the ownership of things. The institution of personal ownership appears to have a long history – perhaps having its origin deep in the prehistoric past (Pearce 1995). The exclusive right to control the use of an object allows the unopposed exercise of one's will, ingenuity and perseverance in the world (Ryan 1983: 231). The exclusiveness of ownership allows the easy transfer of objects – and attendant rights over their use – from one person to another (Ryan 1983: 231). An efficient system for the allocation of such rights includes full specification of the rights, separability of different rights (which can then be allocated to different individuals or groups), arrangements for their transfer, security and enforceability of arrangements, low transaction and administration costs, and equitable distribution (Young 1992: 99-116). Once they are allocated, different kinds of property arrangements allow us to distinguish between objects. We can, for instance, make distinctions on the basis of specific ownership, such as those objects which are mine, those that are yours, and those that belong to others. We can also use categories of ownership to distinguish between types of object: those that can belong to individual owners, those that must belong to institutions such as the State, and those that maybe belong to no one. Having done so, we can also distinguish those objects that can only be transferred from one owner to another by particular mechanisms: accordingly, we can identify those that can be transferred by way of trade, purchase and sale; and identify as different those that can only be transferred by way of gift, such as engagement or wedding tokens; and we can distinguish from both of these other objects that, like wedding tokens once given, remain the property of the recipient until death or some other catastrophe intervenes. It is not the argument of this book that property itself is entirely inappropriate:

but it is the aim to suggest that the archaeological heritage falls within the category of those objects where exclusive ownership may be inappropriate.

In this light, it is useful to review the work of Alan Carter who sought specifically 'to examine the adequacy of those arguments purporting to justify rights in property' (Carter 1989: viii) and especially those 'which try to derive property rights from the nature or predicament of humanity prior ... to the obligations of civil society' (Carter 1989: 9). While the obligations of a particular civil society require the avoidance of conflict by the acceptance of certain circumstances as 'givens' – among which may be the pre-existing fact of established property rights – arguments from the 'human condition' assume moral universals which operate cross-culturally. For Carter, the arguments from 'labour', 'desert', 'liberty' and 'utility' all fail because it can be shown that they assume property as a precondition of their operation: change the circumstances of their operation and they no longer hold true. The argument from 'first occupancy' – the appropriation for use of a previously unused resource – is a reason for the rise of property rather than a justification for its continuance. The arguments from 'personality' and from 'moral development' fail because 'what property rights allow is the right not to behave morally, [by exercise of] the right to exclude others from what they are in need of' (Carter 1989: 111). The argument from 'human nature' fails because there is no evidence for selfish aggression as a universal and inevitable human trait (Montagu 1976). The argument from 'efficiency' is grounded in economics, but in any case 'Efficiency should not dictate our morals. The most efficient form is what we should attempt to ascertain only after the moral questions have been answered It is a fundamental mistake to determine our moral goods on the basis of what is most efficient' (Carter 1989: 75).

The detail of the 'efficiency' argument (also cited by Merry-

man [1994: 41] in the case of cultural property) turns on the oft-cited 'tragedy of the commons', which purports to demonstrate the inevitably destructive consequences of common ownership. Carter (1989: 67-9) gives two examples of such arguments.

Cows in a field Several farmers each own a number of cows which all graze together on grassland owned by none of the farmers but to which they all have equal access. Because the grass is a free resource to all the farmers, it serves their individual interest to place as many cows as they can afford to buy on the grassland. Since each farmer will do so, the grassland is soon depleted, ceases to be a resource available to any of them and in the long run cattle ceases to be a viable industry.

The usual solution proposed is to place the grassland in the ownership either of one of the farmers or of somebody else. Since the farmers will now have to pay for use of the grass – either as rent to the owner or, if the farmer is the owner, by virtue of having paid for the land on purchase – they will have a direct interest in maintaining that resource (Carter 1989: 68).

Trees forming a windbreak Several individuals own communally a number of trees in a line which provides a windbreak for all of them. They also hold the right to cut individual trees to provide wood for fuel. Several individuals each decide to cut one or more of the trees for fuel, the consequence of which is the loss of the windbreak for all.

The solution put forward is the private ownership of the line of trees by one individual, which will give that individual the power to charge for the removal of trees and an interest in maintaining the windbreak for their own benefit. Trees will thus be available for use as fuel without the

attendant risk of loss of the windbreak (Carter 1989: 68-9).

As Carter points out, the problem in these cases is not that of communal rights in a resource, but its combination with contra-dictory private rights. In the case of the cows, the private ownership of the cows is what allows over-use of the common grass because of each owner's interest in increasing the size of the individual herd: if the cows were also all jointly owned, then only the optimum number would be grazed, maintaining both cows and grass (Carter 1989: 68). In the case of the windbreak, the problem is not one of communally-held rights but of overall control of the resource of the windbreak: this can be achieved by establishing mutually-agreed rules for the cutting of individ-ual trees such that the integrity of the windbreak is not im-paired (Carter 1989: 68-9).

In both these cases, not only is the introduction of property rights not the only viable solution, but it is the introduction of a private property element that creates the problem to be solved. Moreover, the reason for introducing property rights as the solution is grounded in the principle that the costs and benefits of individual actions should rebound on the owner and user of a resource. This is the economic principle of 'externality': that the costs of the effects of an individual's actions on others, such as pollution, 'must be borne by those who produce them' (Carter 1989: 71). However 'all that is [really] required ... is to make those who produce such externalities responsible for them, [which is] not the same thing as giving them ownership rights' (Carter 1989: 70). Indeed, ownership rights can reverse the principle in practice: 'internalities' can be externalised, as in the case of putting redundant employees on State benefits (Carter 1989: 72).

In arguing for individual ownership, the role of the commu-nity is also often forgotten. A community may be considered

equally likely to be concerned to see a resource pass to its descendants as an individual (Carter 1989: 73), and especially so when one recalls that ownership rights include that of the destruction of the resource (Carter 1989: 75). Arguments for the ownership of property on the grounds of its conservation are thus specious, and against them Carter puts an alternative rule: 'use any resource you like as long as it is not being used at that particular moment by someone else' (Carter 1989: 85). Such a rule assumes the future availability of a resource to others.

In justifying this 'right to temporary possession' as an alternative to permanent private ownership, Carter points out that property rights are relational, and the central relation is one of exclusion by the owner of all other people (Carter 1989: 128). Property rights are a complex of various unequal rights and duties – rights of use and access to a resource on the part of the owner, duties to abstain from use or access on the part of others (Carter 1989: 129) – in which availability for private *use* is confused with *exclusive* property *rights*: the right of temporary possession does not exclude the possibility of exclusive use, but only under a system of voluntary control rather than a coercive imposition (Carter 1989: 139-40).

It is thus the exclusionary nature of private property supported by the coercive power of law that is objectionable. O'Neill (1993: 171) argues for an 'institutional context in which ... a wider and more satisfactory conception of the goods of life is made possible and encouraged' than in the purely economic and acquisitive market. His emphasis is on the creation of cross-generational community for the conservation of the environment (O'Neill 1993: 34-5) since a 'humanized environment contains within it the presence of those who created the land' (O'Neill 1993: 41). The institution of the market is the specific enemy of such communities because by promoting individual mobility it works to destroy ties to place and

cross-generational communal ownership of the environment (O'Neill 1993: 42-3).

Property and non-property alternatives

The idea that property and the market in themselves are morally wrong is not a new one (see for instance Ryan 1984). In particular, anarchist theory (Woodcock 1975; 1977) has sought viable alternatives.

Individualism. For William Godwin,

> there are three degrees [of property]. The first ... [and only legitimate one] is that of my permanent right in those things, the use of which being attributed to me, a greater [total] sum of benefit or pleasure will result, than could have arisen from their being otherwise appropriated Hence ... no man may ... make use of my apartment, furniture or garments, or of my food, in the way of barter or loan, without first having obtained my consent (Godwin 1971 [1799]: 282).

The two other degrees of property – of the produce of one's own labour or what falls by chance into one's hands; and the produce of the labour of others – are both a form of 'usurpation' (Godwin 1971: 283) because they defy the first kind of property right. Godwin, who also believes in the perfectibility of humanity, thus calls upon human reason to be the arbiter of the distribution of goods: whoever reason says will cause the greatest benefit by use of an item shall have possession of it, and no one else. Since individuals can also demand 'the forbearance of others' (Godwin 1971: 282) in their dealings, the judgement of reason is absolute and no dispute shall arise.

Here the relational qualities of property identified by Carter

(1989: 129) are reversed: instead of a right to deny to others use and access, there is an implied duty of use of the item to create 'benefit or pleasure' (Godwin 1971: 282). Failure to create such benefit will result in an abrogation of the individual's right to the item. Here, the focus is placed upon use rather than exclusivity.

Mutualism. Godwin's vision can be criticised on the grounds that, while it ensures the autonomy of the individual, it fails to provide a clear idea of how human beings will behave socially: Godwin's rational individual is ultimately a cold and lonely figure among other such individuals.

Pierre-Joseph Proudhon's alternative solution – based upon the idea that humans naturally come together to produce – is that of 'a great federation of communes and workers' cooperatives, based economically on a pattern of individuals and small groups *possessing* (not owning) their means of production, and bound by contracts of exchange and mutual credit which will assure to each individual the product of their own labour' (Woodcock 1975: 17, emphasis added). 'The values of all the commodities being measured by the amount of labour necessary to produce them, all the exchanges between the [individual] producers could be carried on by means of a national bank, which would accept payment in labor checks – a clearing house establishing the daily balance of exchanges between the thousands of branches of this bank' (Kropotkin 1970: 160). This is also an idea developed in the 'time store', where the cost of goods to customers was divided between the cost to the store in terms of money actually paid, and a credit slip for the time spent by the storekeeper in filling the order; the latter was redeemable by the storekeeper in terms of the customer's own (specialist) labour time (Warren 1852, quoted in Woodcock 1977: 340-9). Thus,

[it is] industrial organization that we will put in the place of government In place of laws, we will put contracts. – No more laws voted by a majority, nor even unanimously; each citizen, each town, each industrial union, makes its own laws. In place of political powers we will put economic forces. In place of the ancient classes ... we will put the general titles and special departments of industry; Agriculture, Manufacture, Commerce, etc. In place of standing armies, we will put industrial associations. In place of police, we will put identity of [economic and social] interests [What] need have we of government when we have an agreement? Does not the national bank, with its various branches, achieve centralization and unity?.... [Do] not the industrial associations for carrying on the large-scale industries bring about unity? And the constitution of value, that contract of contracts ... is not that the most perfect and indissoluble unity? (Proudhon 1851, quoted in Woodcock 1977: 295-6).

Here again, possession is predicated upon use; and access to produced goods is by virtue of mutual agreement in the form of contracts of exchange for equal value, rather than the enforcement of abstract and preordained rights.

Collectivism. Proudhon's vision of individual possession of the means of production was ultimately unsuited to mass industrialisation. Accordingly, Michael Bakunin and his followers adopted 'the idea of possession [of the means of production] by voluntary institutions, with the right to the enjoyment of his individual product or its equivalent still assured to the individual worker' (Woodcock 1975: 18). Where collectivism differs from mutualism is 'in taking association [not simply] as a *means* of dealing with large-scale industry [as mutualism did, but] turning it into a central principle of economic organization.

The group of workers, the collectivity, takes the place of the individual worker as the basic unit of social organization' (Woodcock 1975: 152, emphasis in original). It is 'a voluntary association that unites all social interests, represented by groups of individuals directly concerned with [those interests]; by union with other [such] communes it produces a network of cooperation that replaces the state' (Woodcock 1975: 187).

Possession for use here is vested not in the individual but in the group, so that all things are held in common by a voluntary self-regulating collective. Access to the products of labour remains by virtue of the labour-cheque (Kropotkin 1972a: 176).

Communism. It is this latter point that is Peter Kropotkin's objection to the collectivist arrangement.

> The collectivists say, 'to each according to his deeds'; or, in other terms, according to his share of services rendered to society [This] principle, at first sight, may appear to be a yearning for justice. But in reality it is only the perpetuation of injustice. It was by proclaiming this principle that wagedom began [at which point] the whole history of a State-aided Capitalist Society was as good as written; it was contained in the germ of that principle (Kropotkin 1972a: 183-4).

Kropotkin's objection is grounded in a denial of the validity of the labour theory of value accepted by Marx (1949), conventional nineteenth-century economics and by individualist, mutualist and collectivist anarchists alike. 'In every case of [an economic proposition] there is an 'if' – a condition. In consequence of this, all the so-called laws and theories of political economy are [grounded in the conditions of capitalism]. So far academic political economy has been only an enumeration of what happens under [the] conditions [of wage-labour] – without

distinctly stating the conditions themselves. And then, having described *the facts* which arise in our society under these conditions, they represent to us these *facts* as rigid, *inevitable economic laws*' (Kropotkin 1970: 179, emphasis in original). Accordingly, what 'the anarchist communists denied is that there is any necessary connection between economic price or value [of things] and moral worth or desert [of people]. Price is determined by a number of factors, such as costs of production and supply and demand. Moral value or worth is subjective and unascertainable' (Graham 1989: 163). It therefore followed that, while 'the local commune and similar associations [were] the proper guardians of the means of production; [the anarchist communists] ... revived the idea ... of a literal communism that would allow everyone to take, according to his wishes, from the common store-houses, on the basis of the slogan: "From each according to his means, to each according to his needs" ' (Woodcock 1975: 18). This is 'the point that differentiates Kropotkin from [mutualists and collectivists] In a voluntary society [the wage system] no longer has any place' (Woodcock 1975: 187-8).

In anarchist communism all trace of the right to exclude and to enforce rights by coercion is eradicated, to be replaced by a system of possession by voluntary associations of individuals with the right of all to the use of all they require without restraint.

All anarchist thought – individualist, mutualist, collectivist and communist alike – is directed towards the construction of a new society in which mature individuals each take full responsibility for themselves and their lives and voluntarily co-operate with others to meet their needs and desires. Cahill (1989: 240) conveniently sums up anarchist thought on economics as 'two fascinating and important strands Anarcho-syndicalism is one, and the "gift economy" is the other'. The former 'has some affinity to ... trade union organizing' (Cahill 1989: 240)

through the identification and use of 'the revolutionary trade union both as an organ of struggle ... and also as a foundation on which the future free society might be constructed' (Wood-cock 1975: 18). The 'gift economy' emphasises the denial of property inherent in anarchist thought and the creation of community it thus engenders. Indeed, anarchism is itself a form of gift economy since it requires individuals to give of themselves to others in the creation of a truly free community of equals: 'freedom for everybody and in everything, with the only limit of the equal freedom for others; which does *not* mean ... that we recognise, and wish to respect, the 'freedom' to exploit, to oppress, to command, which is oppression and cer-tainly not freedom' (Malatesta 1977: 53, emphasis in original).

Propertyless culture

Hyde (1983) seeks to understand artistic endeavour as the product of a 'gift', and his study concludes with a review of the gift element in poetry as understood and expressed by Whitman and Pound: 'the primary commerce of art is a gift exchange [and so] unless the work is the realization of the artist's gift and unless we, the audience, can feel the gift it carries, there is no art'. Consequently art is in danger from economics because 'a gift can be destroyed by the marketplace' (Hyde 1983: 273). Drawing on ideas especially from Mauss (1990), two immediate qualities of the gift become evident. Firstly, 'the gift must always move' between people or cease to be a gift (Hyde 1983: 4). This is not necessarily the object given as gift, but the gift element of the object. Secondly, and by virtue of the motion inherent in the gift, 'the gift must always be used up, consumed, eaten. *The gift is property that perishes*' (Hyde 1983: 8, empha-sis in original), but not for the recipient, only for '*the person who gives it away*' (Hyde 1983: 9, emphasis in original). Accordingly, in giving the gift away or in jointly consuming it with others 'it

is not [really] used up ...: the gift that is not used up [or passed on] will be lost [i.e. will cease to be a gift] while the one that is passed along remains abundant' (Hyde 1983: 21) by establishing a circle of reciprocity (Hyde 1983: 15-16).

Gifts thus contrast with commodities since commodities are 'used up' when sold in the sense that nothing about the exchange ensures the commodity's return (in Appadurai's [1986] terms, it ceases to be an item for exchange). The 'commodity [while temporarily a commodity] moves to turn a profit [while] the gift [always] moves towards the empty place' (Hyde 1983: 23). The value of the commodity is fixed by the value given for it, while gifts are bound to increase in value as they move, especially when a circulation of gifts creates community out of individual expressions of goodwill (Hyde 1983: 37). 'It is the cardinal difference between gift and commodity exchange that a gift establishes a feeling-bond between two people, while the sale of a commodity leaves no necessary connection' (Hyde 1983: 56). Accordingly 'we do not deal in commodities when we wish to initiate or preserve ties of affection' (Hyde 1983: 65-6). Commodities thus move 'between two independent spheres A gift, when it moves across the boundary [between people or groups], either stops being a gift or abolishes the boundary. A commodity can cross the line without any change in its nature; moreover, its exchange will often establish a boundary where none previously existed' (Hyde 1983: 61). The independence of the commodity is essential, for a thing that has market value 'must be alienable so that it can be put in the scale [with other things] and compared' (Hyde 1983: 62), but 'Emotional connection tends to preclude quantitative evaluation' (Hyde 1983: 66). The result is that a 'circulation of gifts can produce and maintain a coherent community, or, inversely, ... the conversion of gifts to commodities can fragment or destroy such a group' (Hyde 1983: 80). It is in this sense that the gift economy is one of 'anarchist property' (Hyde 1983: 84) because 'both anarchism

and gift exchange share the assumption that it is not when a part of the self is inhibited and restrained, but when a part of the self is given away, that community appears' (Hyde 1983: 92). Art – Hyde's particular concern – is one form of such a gift, and 'we know that art is a gift for having had the experience of art. We cannot know these things by way of economic, psychological or aesthetic theories' (Hyde 1983: 280).

This discussion of the gift brings us to the one of the topics of the next chapter. The shift of the object from commodity to gift is a shift from a realm of use value to one of symbolic value (e.g. Baudrillard 1981) marking a change from an object embedded in systems of ownership and exchange for measured value, to the status of culture, the realm of heritage related to identity and – more importantly – the creation of community by the gift of the self. Reduction of symbolic value to use value by treating the heritage object as if it is a commodity thus represents a form of the private appropriation of the gift increase inherent in heritage, turning it into private property: it does not matter whether this is achieved by a private individual in the name of the market or by a corporate body such a museum or an organ of the nation-state in the name of 'the public'. It is by treating the heritage as an object of *ownership* that its reduction to a commodity is effected and the gift increase that represents the creation and maintenance of community is thereby taken away. If 'Property is Theft' (Woodcock 1975: 105, after Proudhon 1840) then the category of Cultural Property should be considered no less than the theft of culture.

Archaeological values

Understanding the concepts of value applied to archaeological material has formed an important strand of my work in the field of AHM and much of what I have to say has therefore already been published (see Carman 1990; 1996a; 1996b; 1998; 2000; 2002: 148-78; 2005; Carman et al. 1999; and see Mathers et al. 2005). It is worth returning to the topic once again here, though, since it is through the application of values to archaeological material that our attitudes towards it are represented, and it is through ideas about value that the treatment archaeological remains are afforded gains respectability. Issues of value and ownership are thus closely linked and both need to be understood if the discussion of ownership is to be undertaken meaningfully.

A 'public' heritage

There is a wide measure of agreement in the literature of AHM that archaeological remains and their treatment are a matter of 'public' concern. McGimsey's (1972) seminal text *Public Archaeology* argued the case for legislation to protect archaeological material on the basis that such material was inevitably a matter of public concern. This principle is the position from which AHM practitioners proceed: they act as the guardians of items representing a 'public good' (Fowler 1984: 110), and of items preserved 'in the public interest' (Cleere 1989b: 10). What is not clear is from where this 'public interest' derives and why

it is given such emphasis in AHM. Indeed, there is very little questioning of the nature of this 'public' concern and there have been few attempts to understand it by archaeologists and other students of heritage.

The conventional argument is that 'the past [inevitably and by right] belongs to all' (Merriman 1991: 1), but this does not lead logically to the conclusion that all humans have an interest in the preservation of archaeological remains. Merriman's survey of public attitudes to the past in Britain established one connection between the kind of knowledge of the past generated by archaeology and certain groups of people; and a separate connection between a very different – much more personal, family-oriented – past and other groups of people. These findings suggest that a general public concern with archaeology does not exist. Accordingly, there is the perceived need to create such an interest by various means, and this is recognised by writers in the AHM field: both McGimsey (1972) and Cleere (1984b: 61-2; 1984c: 128) press the case for programmes of public education, and McGimsey (1984) offers advice as to how to 'sell' archaeology to non-archaeologists. Nevertheless, the literature of heritage management abounds with a limited concern with 'the public' as groups of people: as visitors, tourists, sources of revenue and capital funding, as audiences and as customers (Cleere 1989b: 10; Merriman 1991; Walsh 1992; Boniface and Fowler 1993; Carman 1995b).

This limited sense of the heritage as a 'public' phenomenon contrasts with that taken towards 'public' things in other disciplines, especially those with which AHM inevitably interacts in its concerns for the contemporary environment of archaeology (e.g. Carman 1996b: 175-8). In popular usage, the 'public figure' is rarely someone to whom the 'ordinary' individual has access. A sociologist of knowledge notes that 'the cleavage between the private and public spheres [of life] is a basic principle of modernity' (Berger 1973: 104). In sociology there has long been a

recognition that the public interest does not equate with direct access by individual members of the population but refers instead to a specific domain of social action (Benn and Gaus 1983a; 1983b). Giddens (1984: 197) similarly remarks that a 'private sphere of "civil society" is … in tension with … the "public" sphere of the state'. In economics, the concept of 'public goods' by no means excludes the possibility of their non-availability for use by individuals (Cole 2002: 135). These sociological and economic understandings that the 'public realm' of social life can have nothing to do with actual people has been combined into a recognition of its strongly corporate nature, which carries an aura of 'otherworldly morality' (Douglas and Isherwood 1979: 29).

While archaeologists, historians, anthropologists and others have sometimes universalised the division between public and private in order to provide convenient and useable analytical categories (e.g. Mehrabian 1976; Thomson 1977; Sassoon 1987; Wilson 1988; Helly and Reverby 1992; Swanson 1992; Turkel 1992; Bold and Chaney 1993), these realms as we understand and recognise them are entirely modern (Benn and Gaus 1983b: 25). The public/private distinction always presupposes 'a secular society in which individuals confront each other in the context of a legal framework upheld by the state, the institutional embodiment of the public – everyone' (Benn and Gaus 1983b: 25). The division first opened up during the later medieval period and early modern period (Backschieder and Dykstal 1996), at the same time as land was appropriated for private use (Way 1997), as houses were divided into separate rooms (Johnson 1993) and the nature of power and its exercise changed (Foucault 1977). By the nineteenth century the two realms were clearly separate: *'public*, as opposed to *private*, is that which has no immediate relation to any specified person or persons, but may directly concern any member or members of the community, without distinction' (Sir George Cornewall

Lewis in 1832, emphasis in original; quoted in Benn and Gaus 1983a: 32). The 'public interest' today represents the generalised good of 'the group as a corporate agent' (Benn and Gaus 1983a: 39), and has become institutionalised and abstracted (Benn and Gaus 1983a: 39-43) so that 'the public interest' is paramount over individual rights and is taken to represent the balancing of all such rights (Gavison 1983). It is affirmed and reified by processes of 'social poetics' – forms of social performance related to styles of rhetoric and whose purpose is to reify social institutions such as the state and its bureaucracies and thus to 'literalize' such necessary fictions as an iconic 'national character' (Herzfeld 1997).

This abstract, institutionalised and rhetorical understanding of things 'public' is applicable to the heritage as a phenomenon because it is as an abstracted, institutionalised and rhetorical phenomenon that the heritage gains its place as a concept. The heritage as a whole consists of individual objects, but as a category into which objects are put it displays attributes of the abstracted, institutionalised and rhetorical nature of modern society itself. Accordingly, the qualities of a heritage object – the 'amount' of heritage it represents – can be measured along the dimensions of the distinction between the 'public' and the 'private'. Ruth Gavison (1983) lists the dimensions of 'publicness' as: being known, accessibility, ownership, control, accountability, effect and intimacy, while Benn and Gaus (1983b) reduce these to three only. For them, *access* (Benn and Gaus 1983b: 7-9) incorporates being known, physical accessibility and the degree of intimacy one may achieve with the object. *Agency* (Benn and Gaus 1983b: 9-10) concerns the powers exercisable in relation to the object, and especially those of the public official whose authority may exceed that of the individual citizen but which are also tightly constrained by law. Here we also enter the realm of bureaucracy as defined by Berger (1973), which is to matters social as technology is to things

mechanical: its purpose is to impose 'rational controls over the material universe' (Berger 1973: 202). The bureaucrat typically displays limited competence which requires the capacity to refer other questions elsewhere for coverage by an appropriate but different agency (Berger 1973: 46). The bureaucracy is always orderly (Berger 1973: 50), demonstrating 'general and autonomous organisability' (Berger 1973: 53), which gives an impression of system predictability and consistency, equivalent to a 'general expectation of justice' (Berger 1973: 52). The sum of all these qualities is a kind of 'moralised anonymity' (Berger 1973: 53), akin to the 'accountability' required of public institutions (e.g. Carnegie and Wolnizer 1996, and see below). Accordingly, agency incorporates issues of accountability and effect. *Interest* (Benn and Gaus 1983b: 10-11) represents a 'diverse cluster of rights of ownership and control' (Benn and Gaus 1983b: 10). These three dimensions of 'publicness' interact, cross-cut and compete to create and represent the complexity of heritage as a modern phenomenon. This is one reason why it is a difficult issue to approach without over-simplification – such as the reduction of 'heritage' to a 'looted' history (Lowenthal 1996), to a 'popular' history (Walsh 1992) or to a 'nationalist' history (Wright 1985).

Value regimes in archaeology

A review of the literature of AHM reveals essentially three types of value that can be ascribed to archaeological material in the public realm (Carman 2002: 148-78). These value types can usefully be understood in terms of a common structure: each derives from a key principle of AHM practice; each is derived from a discipline external to archaeology; and each results in particular value ascriptions (summarised in Table 3.1). In large measure, each of these can also be related to a particular kind

of managing institution, and to a particular kind of language which is deemed appropriate (summarised in Table 3.2).

Table 3.1. Value types in archaeology

Value regime	Key principle of AHM	Discipline(s) from which derived	Value ascriptions
Accountability of institutions	No private archaeology (McGimsey 1972)	Accountancy	Financial/ monetary
Useful	Selection ... imperative (Cleere 1984c)	Economics	Use and non-use
Social	Non-renewable ... to be preserved in perpetuity (Cleere 1984c)	Anthropology/ Philosophy	Symbolic and 'otherworldly'

Table 3.2. Consequences for archaeology of value types

Value regime	Relevant institution	Language applied
Accountability of institutions	Museum	Exclusivity Commodification
Useful	State	Custodianship Stewardship
Social	Community	Morality Otherworldliness

3. Archaeological values

Accountability of institutions

That there is today a flourishing trade in antiquities is well known (and see Chapter 1). What is perhaps less well known is that museums in some parts of the world are being required to behave towards their collections as if they are items for sale: to place a financial value or 'price' on them. This is currently the case for financial reporting purposes in Australia, where the provisions relating to assets in *Australian Accounting Standard AAS29* on 'Financial Reporting to Government Departments' became operative in July 1997 and requires precisely this type of valuation for 'assets [which are] "difficult to measure"' (AARF 1993; 1995).

This approach is grounded in the notion that museums are public institutions and thus need to justify their expenditure of public money by showing how valuable they are to the community. It is held that a financial measure is an appropriate one and that such a valuation makes the activities of the institution more 'transparent'. Several ways of measuring the financial value of museum collections have been put forward by accounting professionals, and discussion of the merits and demerits of this system has therefore largely been confined to the literature of accounting, particularly in Australia (Carnegie and Wolnizer 1995; 1996; 1999; Hone 1997; Micallef and Peirson 1997; but see also Carman et al. 1999). This system currently applies only to museum collections but there is no reason why the approach cannot be extended to other types of 'collections' including sites and monuments in State care, or those protected under scheduling provisions or as National Monuments or in National Parks (Micallef and Peirson 1997: 32 and 36). As noted in Chapter 1, placing a market value on antiquities is also justified as part of a campaign for a 'licit' international trade in ancient objects (Merryman 1994). Where a market value is not available (as, for example, where no market exists for an item)

other alternatives have also been proposed (see Carman et al. 1999: 144; Darvill 2005: 30-1).

The language of accounting is especially that of exclusivity. Since the institution holding the collection is assessed in terms of the value of that collection, the collection itself is deemed relevant only to the holding institution. Inevitably, this treatment of the items in the collection as objects in their own right and owned exclusively by the institution concerned also serves to treat them in the same way as any other owned object. Accordingly, objects in such a collection can be seen as a store of tradeable value, effectively categorising them as commodities. This is not the same argument that Merryman (1994: 55) dismisses as 'an effete prejudice' (see Chapter 1): instead it is the realistic recognition that only a commodity item can be deemed to represent a monetary value, since money is a mechanism for trade. That museum objects are not in fact usually bought and sold is irrelevant here: by ascribing to them such a measure of value, they fall within the realm of commodity treatment. It is accordingly entirely appropriate that these objects should be considered the sole property of the holding institution, for only that institution can claim the right of proper disposition of the object and access to the value it represents. Thus, exclusivity and commodification work together to support the role of the collection in giving value to the holding institution.

The main advantage of this 'accounting' school of value is that it recognises the value of cultural objects on a universal scale. It also gives archaeologists a medium whereby we can deal with others, since financial terms for the purchase of items can be offered, which is effectively the system operating in Britain in respect of the law of Treasure (Department of National Heritage 1997: 25-9); financial inducements can be offered to encourage others to desist from looting or damage; payment for access to sites and material may be made, or offers

of employment as part of a research team. The disadvantage of such a value scheme is that it represents a very narrow sense of the idea of value.

A useful 'economic' heritage

There is sometimes a tendency among archaeologists to be scathing about 'the dismal science' of economics. This is based upon the misconception that all economists care about is money: not true, for economists take a sophisticated approach to questions of value, grounded in the recognition of the environment as a scarce (that is, finite) resource.

From the perspective of economics, the environment comprises both renewable and non-renewable elements (Young 1992: 9; Brown 1990) and most economic efforts have been put into considering renewable and potentially renewable components (Young 1992; Orians et al. 1990). This is of limited help to archaeologists, who consider their material to be finite and non-renewable (Cleere 1984c: 127; Darvill 1987: 1; McGimsey 1972: 24). Nevertheless, the general scheme of value applied by economists has been borrowed for application in archaeology. This scheme is of two main types of value: use values and non-use values (Young 1992: 23), sometimes called nonconsumptive values (Brown 1990: 214). Included in non-use values are types of future uncertain nonconsumptive value (Brown 1990: 214-17): option value (Young 1992: 23) and bequest value (Young 1992: 23; Brown 1990: 215).

These types of value have been introduced to archaeology especially by Darvill (1993; 1995; 2005) who approaches value by providing lists of the specific types of value that will fall under each heading provided by the economists (Table 3.3). Under 'use value' he lists those of 'archaeological research', 'scientific research', 'creative arts', 'education', 'recreation and tourism', 'symbolic representation', 'legitimation of action', 'so-

cial solidarity and integration', and 'monetary and economic gain' (Darvill 1993: 12-20; Darvill 1995: 44-5). Under 'option value' he lists 'stability' and 'mystery and enigma' (Darvill 1995: 46-7) and under 'existence value' he lists 'cultural identity' and 'resistance to change' (Darvill 1995: 47-8). Exercising the option latent in the option value converts that value into a use value: option value is therefore no more than a deferred use value. The same, however, applies to existence and bequest values: these too are simply deferred use values because they describe uses that may be acted upon in the future. In fact, all these apparently different values represent the productive but not necessarily destructive *use* of the item in question: the only doubt is to when that use will take place and what type it will be.

Table 3.3. Co-existing heritage values

Use value	Non-use value	
	Option value	**Existence value**
Research	Social stability	Cultural identity
Creative arts	Mystery/enigma	Resistance to change
Education		
Recreation/tourism		
Symbolic representation		
Legitimising current action		
Social solidarity		
Monetary gain		

In other words, the 'economic' school is concerned with what benefits individual components of the heritage are able to provide. This is essentially the approach taken in schemes that attempt to assess the 'importance' of sites in the UK (Darvill 2005; Darvill et al. 1987), or their 'significance' elsewhere (Bruier and Mathers 1996). It is a scheme which assumes various alternative uses for a site or a body of material: exactly Martin Carver's (1996) starting point in his consideration of

archaeological value. This is the approach taken by economists, who recognise that since the value with which they are concerned only arises at the point of making a decision, then 'different decisions may require different concepts of value and [thus] different valuation methods' (Sinden and Worrell 1979: 411). Here it becomes evident that the values measured or recognised by economists always relate to the comparison of one thing with another, which is exactly what 'archaeological significance testing' is about (see also Baudrillard 1981: 29, who calls all such values exchange values). Rather than a commodity exchange value (which is perhaps what the 'accounting' school of value discussed above offers), this scheme relates especially to the functional utility of heritage objects to the owning and controlling body, most commonly the State.

The State is a single body claiming to act for a collective entity, its citizens. Unlike the museum – especially when the museum is applying an 'accounting' type of value to heritage objects – the State may not claim exclusive property rights, but will take to itself certain key powers of use and disposition which will allow it to act as the preserver of an object. The language then applied is that of stewardship and custodianship rather than of ownership, but in practice it will amount to the same thing (for more on this, see Chapter 4). As steward or custodian, however, the State is denied one of the key rights attached to exclusive ownership – that of disposal. Accordingly, the role of steward is one held in perpetuity, so that the object itself is also deemed to be one to be preserved for ever. Therein lies the origin of and justification for applying utilitarian values to heritage objects: put crudely, since they must be maintained they may as well be found useful. The kinds of utility then ascribed to heritage objects represent a common store of value for all the citizens of the custodian State, and for others also allowed access such as tourists and visitors. The heritage thus offered may be used by all as an educational and inspirational

resource: this does not, however, mean the passage of owner-ship rights to the citizens themselves, but instead to the State acting as their Trustee.

The advantage of this comparative 'economic' approach to the value of the heritage is that it gives us a usable list of very tangible purposes for having a heritage and treating it as something different from anything else. The disadvantage is that it lifts the heritage into the powerful realm of economics where other non-economic schemes of value have far less authority.

A social heritage

An alternative to these systems of value is the belief that the fundamental purpose of the heritage is simply to be the heri-tage. The institutions that we have established to create the heritage – museums, laws, academic disciplines – are all concerned to set the heritage up as something above and beyond the ordinary, outside the realm of accountancy, 'the audit society' (Power 1997) and the economic (Carman 1996b; 2005).

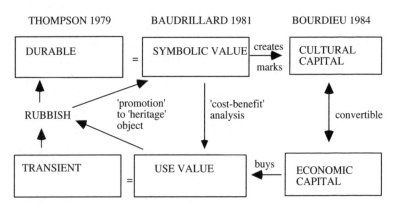

Fig 3.1. **Relationships between economic values and symbolic value**

3. Archaeological values

The starting-point for this value scheme is the recognition that individuals and societies have at their disposal both 'cultural' and 'economic' types of capital which are different but convertible into one another (Bourdieu 1984). The conversion can be effected either directly by individuals via the exchange of knowledge and the use of social position to find more lucrative employment; or more indirectly via the acquisition of commodities which either have or can be manipulated to acquire symbolic 'cultural' value (Baudrillard 1981) (Fig. 3.1). Thompson's (1979) 'durable' and 'transient' types of values can be held to equate with Baudrillard's (1981) 'symbolic' and 'use' value realms, and the dynamic of Thompson's *Rubbish Theory* provides a model of the process by which the conversion from economic to cultural capital is achieved: essentially, one of 'promotion' (Carman 1990). Objects with this symbolic value both mark and serve to create a stock of cultural capital. The reconversion of cultural capital to economic capital is the process by which the symbolic value of the object becomes (by Baudrillard's 1981 'cost-benefit analysis') turned back into use value; which is then capable of measurement and comparison *per* Darvill (1993; 1995), Carver (1996) or in measuring site 'significance' (Bruier and Mathers 1996). But this reconversion to use value is the reversal of the initial promotion to 'cultural' status (Carman 2005).

This scheme of social value should not be seen as the promotion of Darvill's (1995) 'symbolic' or 'research' values to overarching importance, or simply as an acceptance of Carver's (1996: 53) assertion of the importance of research over and above everything else in archaeology. The difference is that in Darvill's scheme, different values vie with each other; and in Carver's, archaeological research vies with other possible uses of land. The point of the 'social' value approach is that it asks what is the purpose of the heritage as a category, not of individual components. The answer derived from philosophers and

social theorists (Thompson 1979; Douglas and Isherwood 1979; Baudrillard 1981; Bourdieu 1984) is that it is there simply to be important and to be kept. It is a form of corporate saving, possessing the 'otherworldly morality' recognised by Douglas and Isherwood (1979: 37). In other words, the archaeological heritage has nothing to do with financial quantification, or with productive use however defined. It is meant to be – in the fullest and best sense – useless; but it is also priceless.

The owning institution under this scheme of value – rather than being a form of stewardship or a trustee relationship – is the community itself. The nature of communal ownership was introduced in Chapter 2 and will be discussed in more depth in terms of its application to the heritage in Chapter 5, but here I want briefly to examine the concept of 'community' as a candidate for an owning institution. In particular, the idea of the owning community needs to be distinguished from that of an agent acting on behalf of the community since this will return us to one of the prior value realms. So, if a museum is appointed (or established) to manage a local heritage, and it does so on the usual basis on which such institutions work, then we may be returned to the realm of exclusive proprietary rights and an accounting model of value. If as an alternative power over the heritage is delegated to a political authority – such as the State or a local representative body – then we are in the realm of custodianship and the economic, utilitarian scheme of value.

No such delegation of authority or rights applies in the social value scheme: here, it is the community itself which acts as owner of the heritage object. However, the community is not a single, corporate entity: it is instead a collective of individuals, and the specific membership of that collectivity will change over time depending upon how the community defines itself. If defined in terms of geography – as a 'local' community – then membership will change as individuals, families, etc. move in and out of the locality. If defined in terms of cultural or biologi-

cal affinity – as a 'descendant', 'ethnic' or 'indigenous' community – then membership will change as individuals die and are born, and as they are recognised as fulfilling the criteria for inclusion or identified as failing relevant tests of affiliation. The community then potentially offers a paradox as an owning institution: it can claim full exclusive rights of ownership unadulterated by custodianship or trustee status, but on the other hand is prevented from exercising rights of destruction or disposal by the claims that can be made by individual members of the community both present and future. This one reason why the 'social' value scheme is couched in a strange language of 'otherworldliness' and sometimes vague claims of moral right, rather than the clearer language of utility: as Douglas and Isherwood (1979: 37) point out, any claims to access and use are made in the name not only of those present but also those absent and the yet unborn.

Conclusion: value and ownership

In a recent paper (Carman 2005), I charted what I have taken to be the 'trajectory' of archaeological material in Britain from a 'heritage' to a 'resource'. The former term designates something valued in terms of the scheme of symbolic and social value outlined above, while a 'resource' is an economic or accounting phenomenon – something to be used, or even used up, in the production of utility. The key difference between a heritage and a resource is that one is not used; but that the other has to be. It is this use as a resource which dictates that it must also be some form of property – since for it to be used someone must have a right of such use.

Lipe (1984) outlines the manner in which the 'cultural resource base' consisting of 'objects, structures, sites [and] human landscapes surviving from the past' is siphoned through types of value deriving from 'value contexts' into the realm of particu-

lar social institutions which then determine the future fate and use of such material (Lipe 1984: 3). That material which is preserved then passes back to form a newly constituted cultural resource base for which the process is repeated *ad infinitum*. Here, it is the values the material carries that determine which is the appropriate social institution to determine its fate, that is to exercise rights of ownership over the object. This is in many ways the conventional view within AHM: that it is the value of the material which determines how it is treated. An alternative view would be to argue that the relationship between property and value works in reverse. This is the model adopted in my own previous work in this area (Carman 1996b). Here, I have argued that the manner in which laws operate upon archaeological material is a threefold sequence: of selection for coverage; of (re)categorisation in terms of the law, including allocation to an appropriate legally-empowered agency; and finally the ascription of a particular kind of value relevant to its particular use.

For the purposes of the argument of this book it does not matter to which view one subscribes, whether value comes first or treatment determines valuation. The key point is the close connection between them: certain types of value are connected to particular types of owning institution. Accordingly, for Lipe associative, symbolic or informational values give rise to public dissemination and access of various kinds, especially as filtered through various types of media outlet. By contrast, economic and aesthetic values make the object subject to government and legal controls, educational institutions, and the paraphernalia of professional interest (Lipe 1984: 3). There is an echo here of the discussion with which this chapter opened: of the perceived split (Merriman 2004) between a public archaeology which represents a generalised and abstract 'public good' (Carman 2002: 97-108) and that at the service of communities and individuals (Carman 2002: 108-12). It is this that first opens up the

possibility of considering alternative forms of property regime in terms of its relevance to archaeology, moving us away from a concern only with exclusive property rights.

4

Archaeology as property

It is the argument of this book that thinking of archaeological remains as kinds of property forces us to understand them and treat them in particular kinds of ways. These ways have nothing to do with the nature of the material itself nor with our beliefs about what we, as archaeologists, do in the world. Instead, we limit our perception of the material and ourselves to suit ideas deriving from realms external to archaeology because these are the areas within which ideas about property and ownership have particular meaning. Like it or not, by considering archaeological material as 'cultural property' we make archaeology not a handmaiden of history even, but of law and economics. The very materiality of archaeological remains, however, has consequences for them in the terms of these very different fields.

The materiality of archaeology

Maurice Godelier (1986) identifies five types of 'materiality', measured on a scale determined by whether they do or do not imply the existence of human beings. The 'infinite past' is always outside the sway of humankind – comprising the climate, the deep subsoil, and fundamental geology. The past transformed by unintentional human intervention includes such phenomena as soil erosion, and changes in vegetation brought about by brush fires. The past directly transformed by humans and requiring maintenance by them includes domesti-

cated animals and plants. Tools and weapons used as exten-
sions of the human body (but not those independent of it, as true
machines are) comprise a fourth type. The fifth type consists of
elements serving as material support for the production of
social life, such as items of wood, bone, leather, and stone used
for building; the metal of machines would also be included here.

Archaeology is widely considered to be the study of artefacts
– things made by human action and thus incorporating items
two to five in Godelier's list, although Godelier himself limits
archaeology to his last two types: 'Once abandoned [tools, weap-
ons and items of wood, bone, leather and stone] fall into ruins –
inert and silent residues of history, prey to the cupidity or
imagination of the archaeologists of subsequent epochs' (Gode-
lier 1986: 4). From the perspective of those who understand
archaeology to be the study of the long-term of the human past
(e.g. Gamble 1993a), however, it incorporates the entire rela-
tionship of human beings with their non-human surroundings
(e.g. Butzer 1982): 'Archaeology is ... palaeoecology in its truest
sense, from the very first appearance of man ... to yesterday'
(Shackley 1981: vii). These surroundings – the first of Godelier's
types of materiality – are what is termed the '(natural) environ-
ment'.

The term 'environment' is used in a number of senses. In
general, and for public consumption, the environment is
equivalent to the realm of *nature*, something distinct and to be
kept distinct from the *human* cultural heritage (Olwig 1989:
132). For the purpose of evaluation, it is a much wider concept,
comprising 'the conditions or influences under which any indi-
vidual or thing exists, lives or develops ... [all] surroundings ...
a combination of physical conditions ...; [and] social and cul-
tural conditions' (Gilpin 1995: 1). For those who seek to
understand and document human interactions with their sur-
roundings, the 'biosphere' is kept separate in a realm of
'nature', relatively unaffected by the actions of humans until

the onset of agriculture and the city (Boyden 1987; 1992). The understanding of 'the environment' in these schemes nevertheless reinforces the dichotomy between 'culture' and 'nature' that is very powerful in modern Western thought. Despite the gradual dissolution of the boundary between the two concepts, as components of nature become directly subordinated to human action (Godelier 1986: 4), the environment and nature are deemed always to be 'what is beyond our own [human] skin' (Simmonds 1993: 3). This 'skin' can be considered to be both our physical outer protective covering and our cultural conception of separateness from the realm of nature.

Godelier's five-point scheme distinguishes interestingly between 'the environment', which is always held to be pristine in its naturalness, and its individual components, which have the capacity to become incorporated in culture by being transformed into artefacts and in due course the focus of archaeological attention (Godelier 1986: 4). The environment is all-encompassing and very large. By contrast, the components of the environment – the source of information concerning it, its role in human history and the effect of human actions upon it – are very small: shreds of natural material, phytoliths, pollen grains, and C^{14} atoms – sometimes called 'ecofacts'.

Eco-facts

Such individual components of the environment are an important source of evidence for archaeologists concerned with human-environment relations: these frequently comprise natural materials and are generally treated as part of nature rather than as artefacts. The interpretations of this material by archaeologists are then often treated by others, such as socio-biologically-inspired 'biohistorians' (Boyden 1987; 1992) as evidence for their own purposes. As Godelier's (1986) scheme indicates, however, it is human action which turns *eco-fact* into

social fact: it is in this sense that ecofacts can be said to precede artefacts.

Shackley (1981) conveniently summarises the materials which are the focus of environmental archaeology – 'an integral part of archaeological science' including the sub-disciplines of bioarchaeology and geoarchaeology which combine with archaeometry to 'extend the scope of archaeological research and blind us with new names' such as 'palaeoethnoparasitology' (Shackley 1981: vii). Her scope covers the realms of non- or partially-organic sediments and soils; micro-organisms from algae through fungi, bacteria and viruses to protozoa and rickettsiae; the realm of plants including ferns and mosses, pollen analysis, wood and charcoal remains, to seeds, fruits and nuts; and that of animals from molluscs through insects and parasites to the bones of animals, fish and birds. Her companion volume for the non-specialist indicates how such data are of value in interpreting the human past in revealing evidence for hunting strategies, food and health, dwellings and settlement patterns, methods of transport, and modes of death and burial: much of this work illustrates how ecofact (natural material) becomes social fact (artefact) (Shackley 1985). Her thematic approach to bodies of evidence is complemented by the more chronological approach taken in works of specific interpretation, whether regional (e.g. Evans 1975) or global (e.g. Roberts 1989), although the latter's 'environmental history' of the last ten thousand years also conveniently lists sources for the 'palaeoenvironmental approach' he adopts (Roberts 1989: 3): dating techniques, especially those reliant on 'natural' phenomena (Roberts 1989: 9-21); palaeoecology, including especially pollen analysis and plant macrofossils (Roberts 1989: 21-30); and geological evidence (Roberts 1989: 30-9).

The difference between Shackley and Roberts in terms of title and self-description may not be entirely insignificant. Luff and Rowley-Conwy reject the term 'environmental archaeology'

as unrepresentative of what they do: 'neither of us has ever sought to reconstruct environments as a primary research aim'; instead, they call what they do 'palaeoeconomy' and 'palaeoecology' (Luff and Rowley-Conwy 1994a: 1). In recent years, the focus of debate in this area has moved towards discussion of the role of the 'environmental' specialist in the research team and especially the integration of the retrieval of environmental information into the research design from the outset (Luff and Rowley-Conwy 1994b) and to the extension of such research into the field of 'public archaeology' (Balaam and Rackham 1992). 'It may seem paradoxical – but environmental archaeology will have achieved its goal only when we no longer call it environmental archaeology' (Luff and Rowley-Conwy 1994a: 3).

Nevertheless, ecofacts remain separate – and continue to be treated separately – from artefacts. As Wenban-Smith (1995: 151) points out, the importance of natural material to the study of the Palaeolithic is difficult to underestimate: 'the Palaeolithic archaeological resource consists of natural Pleistocene deposits, some containing humanly-modified artefacts and others not. The investigation ... of the Palaeolithic period depends, more than for other periods, on the analysis of evidence not caused by human activity.' He then goes on to show how archaeological schemes of management, comprising a sequential process of recognition, inventory, assessment and action (Wenban-Smith 1995: 149) specifically exclude this range of material, including:

artefactually sterile geological context[s] (Wenban-Smith 1995: 151).

artefactually sterile deposits, [comprising] stratigraphic information, environmental information [and] absolute dating potential (Wenban-Smith 1995: 152).

natural geological deposits ... without artefacts [compris-
ing] biological remains [which may be] stratigraphically
significant [and] potentially datable (Wenban-Smith
1995: 154).

quaternary research skills ... [for] excavation [and] sam-
pling ... small mammal[s and] botanical [remains],
quaternary dating techniques [and] recording detail[s
such as] artefacts, other clasts, and sedimentary units
(Wenban-Smith 1995: 156).

To overcome this disabling consequence of the division between
nature and culture, a 'Palaeolithic archaeological resource'
would need to record: the nature of the geological context;
disturbance of the context; absolute datability of the context;
chrono-stratigraphic geological evidence; botanical remains;
faunal remains; and (only after all this) artefactual remains
(Wenban-Smith 1995: 158).

The close connection between natural and cultural remains
in Palaeolithic archaeology is more than a question of method-
ology and the relative scarcity of other types of material. The
Palaeolithic period is one for which similar archaeological con-
cerns are evident throughout the world: the origin and spread
of modern humans (Gamble 1993b); and the origins of language
and of 'meaning' (Hodder et al. 1995: 78 and 81-3). The global
spread of the human species during this long period can be
associated with the ubiquity of the natural environment: here,
if ever, is when humans were most 'at one' with nature (Boyden
1987; 1992). As a branch of 'natural' science, Palaeolithic ar-
chaeology can legitimately claim a global relevance which is
lacking for the study of later periods when specific, individual
and different human cultures emerge in different parts of the
globe. For the Palaeolithic, as for no other archaeologically-de-
fined period, the global relevance of archaeology can be claimed

and its universal value asserted. As Gamble (1993a: 49) has it: 'Examining global colonization provides a means to establish the essential parameters of an evolving humanity.' From this perspective it is possible to derive the universalising policies of a 'world heritage' (Cleere 1989a; cf. Byrne 1991).

Eco-nomics: valuing the environment

Simmonds (1993: 16) points out that whatever understanding of human-environmental relations one subscribes to, there are two concerns currently held to be of global importance: the progressive degradation of the environment; and the depletion of natural resources. Both of these have been caused by human activity. Accordingly, although ubiquitous the environment is nevertheless a scarce (finite) resource and thus amenable to approaches derived from economics. From this perspective, the environment – designated as 'natural resources' (Young 1992: 9; Brown 1990) – comprises both renewable and non-renewable elements. From the perspective of economists, it is the renewability or sustainability of the environment that is its desired characteristic and thus most efforts have been put into considering renewable and potentially renewable components (Young 1992; Orians et al. 1990). This is of limited help to archaeologists, who consider their material to be finite and non-renewable (Cleere 1984c: 127; Darvill 1987: 1; McGimsey 1972: 24).

Nevertheless, the general scheme of value applied by economics to such concerns has been borrowed for application in archaeology (see Chapter 3) and especially by Darvill (1993; 1995; Chapter 3) whose approach to understanding the conception of value is 'based on [peoples'] differences in attitudinal and interest-based orientations' (Darvill 1995: 43). His understanding of value is derived from three 'economic' principles: 'that people most often equate truth with convenience; that we

find most acceptable that which contributes to self-esteem; and that people approve most of what they best understand or are most familiar with' (Darvill 1995: 41). As discussed in Chapter 3, Darvill approaches value by providing lists of the specific types of value that will fall under each heading provided by the economists. Darvill's claim that his value 'systems' represent fundamentally different sets of attitudes and interests in respect of the material (Darvill 1995: 43) can be shown to be false: in fact, all of them represent very similar sets of interest and attitude, concerning the productive but not necessarily destructive use of the item in question; the only doubt is to when that use will take place. This reinforces the 'economic' understanding of value applied here by Darvill, which assumes a large measure of narrow self-interest to individual human beings (the classic economic concept of 'utility' to a given individual) and assumes that social value is a simple aggregate of individual choice-preferences (see Sinden and Worrell 1979: 57-8). For Darvill, value is simply a function of use; and social value identical to a sum of individual values.

In pointing out these weaknesses of applying economic value schemes to archaeology, it should not be thought that this represents a total argument against the application of ideas derived from economics to the valuation of ancient remains. It is an argument against the simplistic application of ideas, but economics is not itself an unsophisticated discipline and still has ideas to offer. Economists themselves are aware of the failings of the 'use value' model and recognise that 'environmental amenity values ... are valuable functions [in themselves] and should not be regarded as "free goods"' (Young 1992: 8-9). This view contrasts with the traditional idea that 'free' or 'public' goods have no value in the economic sense since they are capable of consumption freely and at no (additional) marginal cost (Ordeshook 1986: 212). In similar vein, it is increasingly recognised that 'social value may be a composite of

the values to individual members [of the society], or it may include additional values that accrue to the [social] group as a whole' (Sinden and Worrell 1979: 121). In other words, a group is not reducible to the sum of its individual members. Economic theory remains tied to the analysis of decisions between alternatives, but it is also increasingly recognised that while 'values are only determined in the context of a decision' those values are affected by the decision *process* itself (Sinden and Worrell 1979: 82). The consequence of these insights are summed up by a review of those activities through which utilities (positive values) may be derived: productive activities, where the product of the activity is the source of utility (equivalent to 'use values'); participatory activities, where participation itself provides the utility independent of any product or outcome; and the reception of stimuli from the environment, which provides the utility regardless of other factors present or absent (Sinden and Worrell 1979: 419). While the latter has an affinity with some aspects of 'existence value' as defined by economists (Young 1992: 23; Brown 1990: 215) it differs from Darvill's (1995: 47-8) use of the term by its total independence from context or consequence.

It is commonly assumed (and especially by archaeologists) that the function of economics is to reduce all aspects of life to monetary value. While some economists justify this approach in the realm of conservation since 'if a marketable value is created, then users have an interest in maintaining the supply [of the good, i.e. conservation]' (Goldstein 1990: 248), others recognise that monetary values are only required in certain closely-prescribed circumstances (Sinden and Worrell 1979: 88). Accordingly, some economic arrangements specifically affect the flow of finance to produce a given outcome (Young 1992: 162-6; Sinden and Worrell 1979: 250-334), but others are designed to affect the social, political and juridical context within which actions take place (Young 1992: 99-116). The limited

71

sense of the term 'utility' – originally coined to reflect only use value accruing to individuals – is thereby extended to cover non-use values accruing to groups. At the same time, it is recognised that utility is derived only from the ultimate effect of an activity, not immediate or intermediate ones, so that measuring value requires 'weights ... for each [desired outcome], converts outcomes to utilities and derives [from this] an *index of comparative values* for each alternative [to be decided between]' (Sinden and Worrell 1979: 479-80): in other words, value (while a function of utility) is not identical to it (Sinden and Worrell 1979: 7). Taking this approach, 'useful value information can usually be generated [but only] when decisions are deeply analysed and when the comparative nature of the outcomes is clearly identified' (Sinden and Worrell 1979: 490). On the other hand, the financially-driven market can work for the environment but only where 'resource users are forced to recognise the value of the resources they use, [otherwise] they will tend to overuse them and because of their overuse, aggravate any environmental problems associated with that use' (Young 1992: 153-4).

Accordingly, while use value retains its force as an analytical category, other types of utility and therefore value are also recognised by economists, allowing them to act on the recognition that since the value with they are concerned only arises at the point of decision, then 'different decisions may require different concepts of value and [thus] different valuation methods' (Sinden and Worrell 1979: 411). Here it becomes evident that the value measured or recognised by economists is always an exchange value (Baudrillard 1981: 29) and accordingly these non-use values relate to the process of exchange: for this reason they are classified as 'transaction costs' (Eggertsson 1990: 6). These types of value are particularly the concern of so-called 'neoinstitutional economics (NIE)' (Eggertsson 1990: 6) which recognises that the 'economic approach has not been successful

in explaining certain group actions' because 'modification of social values – that is, changing ideologies – are a major factor in institutional change' (Eggertsson 1990: 72-5). Since 'transaction costs are [specifically] the costs that arise when individuals exchange ownership rights to economic assets and enforce their exclusive rights' (Eggertsson 1990: 14), the ideologies that control, limit and define those rights are worthy of attention. 'Ultimately we are interested in the impact of various structures ... on the wealth of nations Rational individuals will compete not only to maximise their utility within a given set of rules, but also seek to change the rules and achieve more favourable outcomes than was possible under the old regime' (Eggertsson 1990: 12). The structures here referred to are those of property rights, and thus the types of ownership of things that are possible come under examination. This brings us finally to the core but unstated notion which sustains all of the value structures of the economic approach but which ultimately denies the ubiquity of the environment: that value only accrues to things that are in some sense, and in some way, *owned*.

The appropriation of heritage

Elsewhere and independently of the previous argument (see Carman 2002: 194-9), I have outlined the effect on archaeological remains of various kinds of appropriation as a 'political economy' of heritage. Marketable art objects and antiquities represent a store of financial (accounting) value, but more importantly they also represent other non-monetary values recognised by all concerned (Merryman 1989: 353-5). What is thus 'owned' by the acquisition of such objects is not mere financial value, but also the store of symbolic and cultural value the object represents (and discussed as 'social value' in Chapter 3). When held by a public institution, the object's store of symbolic and cultural value serves to create and enhance the

sense of community on behalf of whom the object is held. Where the object falls into private hands, that store of cultural capital accrues not to the community from which it derives but to the individual owner. Accordingly, the private ownership of cultural objects represents the appropriation of a collective cultural store of value for exclusive use. Heritage as a collective store of cultural value is not intended for private ownership; the latter represents the appropriation of a sense of community for the enhancement of an individual's own status, which in turn denies the very purpose of promotion of objects to 'heritage' status (Fig. 4.1).

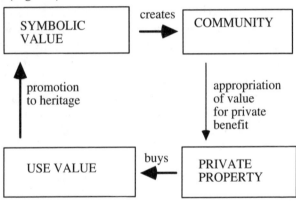

Figure 4.1. Heritage and private ownership

The identical principle applies in the case of the appropriation of cultural items by conquering or colonising states from those conquered or colonised (Fig. 4.2). By seizing items of symbolic 'cultural' value from another's territory and placing it in one's own, that cultural heritage accrues to the conquering or colonising power. With it may pass a sense of identity, as in the case of the swastika-symbol which imbued Nazi Germany with the full authority of an ancient Eurasian culture (Quinn 1994). It may serve to legitimise rule, as with the transfer of 'royal'

symbols to the conquering state (Greenfield 1989: 137-53). Or it may legitimise a claim to cultural continuity, as with the adoption by the Russian Tsars of the imperial double-eagle of Byzantium, and the acquisition by the British Museum of the Parthenon (Elgin) Marbles (Greenfield 1989: 47-105). Here, the purpose of promoting objects to 'heritage' status is fulfilled, but at the expense of the community from which such objects derive. Instead, the store of symbolic and cultural value they represent accrues to conquerors and colonisers from elsewhere.

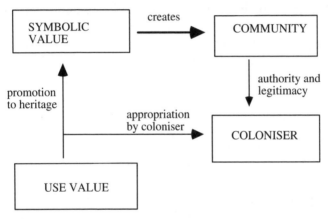

Figure 4.2. **Heritage and colonial appropriation**

The conventional response to the threat to the heritage of looting, private acquisitions in an international marketplace, or appropriation by aggressive outsiders is the strengthening of State controls on heritage objects. Indeed, it is conventionally held that the appropriate form of ownership for heritage objects is that of the State of origin, and under international law it is inevitably States which are required to act in defence of heritage objects. National laws also frequently provide for State ownership or control over heritage objects and sites. This may (as in the UK) be justified on the grounds that the role of the

State is not that of exclusive owner, but of guardian or custodian on behalf of the real owners, who are the wider community or 'public'. Nevertheless, what passes to the State is almost invariably either full ownership or the power to exercise ownership-style rights over the object. In this sense, the State becomes the effective owner of the object. This answer to the problem presented by looters and the market is effective, but has its own consequences for the heritage which are rarely – if ever – considered.

If acquisition by private individuals or by an authority other than the State of origin of an object results in the loss of a heritage object's purpose, we should not suppose that State ownership does anything different. It is much more likely that State ownership diverts heritage value away from the collectivity of members of the community claiming affinity with the heritage object – the community itself as an 'organic' society – and towards the State as an institution. The result here is that the institution of the State – only one of a number of ways in which any society may organise itself – accrues to itself the sense of community carried by the heritage, and thereby affirms its own authority as if it is the natural and only legitimate carrier of a sense of community. The symbolic value of a community's sense of heritage is converted into that of a 'national heritage' from which the nation state only can acquire prestige, in return for exercising control over that heritage. In other words, State 'ownership' of heritage does not fulfil the purposes of the heritage, but instead gives greater prestige and authority to the State as an institution. This connection is mediated through technologies of ownership and control which in turn serve to justify and reify the control over heritage exercised by the State (Fig. 4.3).

In each of these cases the diversion of symbolic cultural value to a different purpose denies the heritage its full purpose. This denial of purpose is inevitable: the heritage is not initially

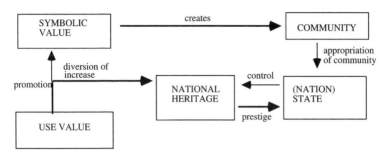

Figure 4.3. National heritage

created as something to be appropriated, but always as something to be shared; the concept of 'my heritage' (but not yours) is a *non-sequitur* since any stock of heritage objects is always 'ours'. The only question is: who here is 'us'? In the case of private ownership, exclusivity of access denies sharing. In the case of colonial appropriation, the sharing is done by or in the name of an exclusive set of others. In the case of State-managed 'national heritage', symbolic and cultural capital accrues to the institution of the State alone. This is the condition of the archaeological heritage in modernity: a child of the division of the 'public' from the 'private' spheres of social existence, it supports also the consequent division of the 'social' and 'political' from the 'economic'. In so doing, its enhanced value is capable of return to the 'economic' realm to provide legitimising power to appropriating institutions or persons, who then exercise rights of exclusive ownership over it.

Consequences of property for archaeology

Chapter 2 outlined some of the advantages of property regimes, as opposed to justifications. Succinctly put, these consist of:

- designating particular categories of object
- discriminating between individual objects

- allocating responsibility and control over objects
- allowing division of responsibility and control
- avoidance of the 'Tragedy of the Commons'.

Each of these can be considered to have some relevance to the archaeological heritage, either positive or negative.

Designation – at least in terms of whether a heritage is 'mine', 'yours' or some other person's – is largely covered above, in the discussion of the appropriation of heritage by private individuals, colonisers or the State. The making of such claims on archaeology (or any heritage) serve to deny any meaning its 'public' status may have, since it ceases to be a truly 'public' object and becomes subject to exclusive rights at the service of particular interests.

Discrimination – especially between the appropriate kind of transfer to which an object may be subject – is, as suggested in Chapter 1, highly relevant. In distinguishing between those objects that may legitimately be transferred commercially, those that may only be transferred by way of gift and those that may not be transferred at all, the issue inevitably arises as to which category – or any other – covers 'heritage' objects and particularly archaeological remains. It is not simply a practical issue of whether there is a market for the sale or purchase of a particular item: such a market may exist, but may also be prohibited by law or custom. Where transfer is allowed, there may be limitations placed upon it: so that only transfer between particular kinds of institution – such as museums – is permitted, or in particular sets of circumstances such as the dissolution of a holding institution and the need to move its collection elsewhere. Particularly in the case of heritage objects, disputes can arise over who has the legitimate right to control the fate of material (see e.g. Layton 1989a; 1989b; *World Archaeological Bulletin* 1992; Carmichael et al. 1994; McDavid and Babson 1997): although representing the allocation of own-

ership rights in such cases, these are never couched in these terms. Instead, the language is one of the uses to which the material may be put, frequently either scientific or ritual.

The allocation and division of responsibility for material and control over its use is clearly also of relevance to archaeological remains. What is at stake here are those rights and duties associated with ownership, as discussed in Chapter 2, whether acknowledged as such or disguised by reference to ideas of custodianship, stewardship or 'trustee' arrangements. The effect is always to allocate certain rights of control to a particular agent (personal or institutional) who then has sole responsibility for exercising them. This is a form of private exclusive property in all but name: it matters not at all whether the agent allocated these powers is individual or corporate in nature, since it is a single entity which exercises them. Nor does it matter overmuch if ownership rights are shared with another, since key rights will be allocated to one party only rather than both jointly: accordingly, while ownership overall may be shared, the right of access or destruction – or to deny these – will be held by one party only. In this sense, so far as heritage objects are concerned, ownership remains sole: while specific rights are distributed between parties, none will be held jointly or in common. The idea of a 'public' archaeological heritage in any real sense of that term is always thus denied: as we treat it, the archaeological heritage is always an object of property.

The so-called 'tragedy of the commons' was addressed in Chapter 2. It forms the basis of one of the key arguments for State or institutional control over archaeological remains: that untrammelled access to such material will lead to its inevitable loss and destruction. On the other hand, Chapter 2 also showed that there are alternatives to dealing with this 'tragedy' which do not involve the allocation of exclusive property rights. This takes us into the territory of the next two chapters, which will consider respectively ideas about heritage as communal prop-

erty and heritage as a non-property resource. This is largely new territory for the field of archaeological heritage management, although as indicated in Chapter 2 not entirely for anthropology nor law and economics. Accordingly, the general approach taken so far in this book has largely been descriptive: the archaeological heritage is in general treated as an object of property, whether this is overtly acknowledged or not, and the aim has been to show how this applies. The tone will now change: we move from what I have called elsewhere the 'language of *is*' – an attempted description of the world as it appears to be – to the 'language of *ought*' – the delineation of possibilities not yet apparent (Carman 2002: 5).

5

Archaeology as common property

As indicated in Chapter 2, the category of 'common' or 'communal' property is generally regarded with suspicion by those who spend time thinking about property relations. For them, such material is subject to a lack of proper control and therefore care, and will fall victim to the so-called 'tragedy of the commons'. This is the fate foreseen also for the archaeological heritage if removed from the realm of formal controls in the form of the exercise of what are, in effect, exclusive property rights.

This chapter, however, takes a different view. Starting from the premise that the heritage is a 'public' good in which a range of divergent interests have a legitimate stake, the discussion will consider in what ways archaeological material can be genuinely considered to be a 'common resource' and how these inevitably different interests can be reconciled within an appropriate structure that will avoid both a tragedy of the commons and the appropriation of the material by one particular interest group. It is also new ground, as indicated at the end of the last chapter: while economists in particular have considered the effectiveness of common property regimes for the conservation of commercially productive resources, they have not yet done so in respect of non-productive environmental resources such as archaeological remains (Cole 2002: 128). This is the direction in which we now turn.

Common property in practice

While the consensus of the disciplines of law and economics has been in favour of private property regimes, some scholars have broken ranks to advocate – or at least study – the potential value of common property systems (e.g. Wade 1987; Ostrom 1990; Thompson 2000). In general, the success stories they relate concern agricultural land use – especially as common pasture – and shared fisheries (e.g. Dahlman 1980; Campbell and Godoy 1992; McKean 1992; Berkes 1992) rather than countryside or heritage protection, and success in these studies is usually measured in terms of sustainable (i.e. ongoing and continued) economic production of cattle or fish. A more strict evaluation criteria that has been proposed, however, consists of the combination of three elements: failure to squander the resource (i.e. no loss of the resource), investment in the resource (i.e. its enhancement) and a lack of anarchy among the co-owners (i.e. ongoing commitment to resource maintenance) (Bromley 1991: 3). None of these in fact require economic productivity in the narrow sense and could be easily applied to assess the conservation of an environmental resource, such as the archaeological heritage.

From a series of studies the economist Elinor Ostrom (1990) has constructed a model of what is required for a successful common property regime, comprising eight key components:

- clearly defined boundaries to the resource
- clearly defined rights in it
- rules that meet the needs of local conditions
- common agreement as to rule-making and amendment
- monitoring of resource use to ensure compliance with rules
- a graduated system of sanctions for rule-breaking, applied by co-owners to each other and to non-owners
- low-cost mechanisms for dispute resolution

- external recognition of and respect for the common property regime in place.

Ostrom (1990: 90-102) also recommends for complex arrangements an additional element: a nested structure in multiple layers. As a list of those factors that will make a common property regime operate effectively, these are all well and good. What they do not do – as Cole (2002: 123) makes clear – is explain why a group of individuals would come together to form a co-ownership scheme in the first instance, especially since there is no historical or other evidence for the inevitability of such structures (e.g. Field 1989). In response, Ostrom (1990: 211) offers the following hierarchy of conditions which encourage the development of a common property system, listing the most desirable first and the least necessary last:

- a shared perception among owners of the advantages of cooperation over non-cooperation
- an expectation of equitability of outcomes from applying rules
- low transaction costs (i.e. the time, trouble and costs associated with maintaining agreement and cooperation)
- a general acceptance among the co-owners that each can be trusted to behave according to the rules
- a relatively small number of co-owners.

In response, Cole (2002: 124-5) argues that these factors can be reduced to a single element: that in fact, each of them contributes to low transaction costs, and accordingly he offers this alone as reason enough for entering into a common ownership arrangement.

The key point that appears to lie at the heart of any successful common property regime, however, is a community of interests among co-owners. It is generally assumed in discus-

sion of these regimes that all the owners will make equal and identical use of the resource and will accordingly require equal and identical access to it, and that therefore benefits and costs will be the same for all. Indeed, in economic discourse at least, the co-owners and users of the resource are assumed to be co-terminus. This works well for economically productive resources, but is perhaps less relevant in the case of environmental resources. Cole, for instance, cites as an example of the extension of the common property idea to the field of environmental protection, that of the Thanet Coast of southern England (www. english-nature.org), by the involvement of 42 stakeholders in the construction of a management–plan (Cole 2002: 127). In doing so, he makes explicit that the concept of 'stakeholder' employed is necessarily wider than that of 'user' and that they represented very different kinds of interest group, including:

> commercial fishing fleets, recreational fishing associations, bikers, bait diggers, horseback riders, hoteliers, jet skiers, water skiers, swimmers, local schools, archaeologists, and environmentalists (Cole 2002: 127).

Interests here diverge widely: from the economic to the purely amenity, from use to non-use, and from use by those directly represented to use by others for whom they may speak or provide facilities.

In terms of the kinds of values recognised by economists (as discussed in Chapters 3 and 4), most are represented:

- direct consumptive uses are represented by fishers, bait diggers, and possibly research archaeologists seeking sites for excavation;
- direct non-consumptive uses are represented by unsuccessful fishers, bikers, horseback riders, jet skiers, water skiers,

swimmers, local schools, conservation archaeologists and environmentalists, although some of these may also result in consumptive use if damage from wheels, hooves, feet, and the wash from watercraft is not effectively controlled;

- indirect uses are represented by hoteliers on behalf of tourists and visitors, by archaeologists and environmentalists.

In terms of the kinds of use value listed by e.g. Darvill (1995; see Chapter 3 above), the following are evident:

- research (by archaeologists and environmentalists)
- creative arts (tourists and visitors)
- education (schools)
- recreation/tourism
- social solidarity (local amenity groups and activity societies – environmental, fishing, sporting)
- monetary gain (commercial use, both direct and indirect, consumptive and non-consumptive).

It is clear that many of these different interests collide. Commercial fishing may affect the availability of stocks for recreational fishing and *vice versa*, while any fishing may impede water sports and swimming, which may also affect the availability of fish. Horseriders and bikers may impede each other, and the presence of both may affect the quality of recreation available. Tourists and visitors – on foot, on horseback or on wheels – may interfere with local use of the resource generally, and educational use by schools in particular. Any kind of use may interfere with environmental or archaeological considerations. In such a case, the idea that each co-owner represents an identity of interest with all other co-owners breaks down. Any scheme of common ownership of an environmental resource must therefore accommodate these different uses, different requirements for access and differences in outcome.

Co-ownership of archaeology

Although economists and lawyers have been slow to examine the role of common property regimes in relation to environmental resources, and especially archaeological remains, archaeologists themselves have been experimenting in just this area. The language of such efforts is not that of property regimes, however: the general reference is to 'community' archaeology (*World Archaeology* 2002), 'collaborative' archaeology (Field et al. 2000; Moser at al. 2002; McDavid 2002) or 'democratic' archaeology (Faulkner 2000; McDavid 2004). Nevertheless, close examination of such efforts reveals a remarkable similarity between these initiatives and the kind of common property regime advocated by transaction cost economists such as Ostrom (1990) and Bromley (1991).

Yvonne Marshall (2002: 216) suggests that in general archaeologists encounter two kinds of overlapping community: one defined by geography is the 'local'; and the other defined by affiliation is the 'descendant', of which the indigenous community is a particular example (Layton 1989a; 1989b; Smith 2004). Either of these – or both – may be involved in an emerging community archaeology project. The issue is primarily, however, not one of who is involved, but the nature of the involvement, and in this connection Stephanie Moser and her colleagues in Egypt (Moser et al. 2002: 221-3) note that there is a standard hierarchy of types of collaboration: 'outreach' represents a one-way process of communication and education; beyond this is a willingness to recognise the contribution to knowledge and information others can make; and beyond this is an active process of consultation, most evident with indigenous and descendant communities. In going further, the project at Quesir in Egypt involved a series of additional steps:

- fostering social relationships with the local community
- maintaining a presence in the community between fieldwork seasons
- employing locals as part of the project
- using locals as the means of outreach programmes
- ensuring the retention of remains retrieved locally in the local area (Moser et al. 2002: 223).

Similar ideas emerge from the work of Judith Field and her colleagues with the Aboriginal community at Cuddie Springs in Australia (Field et al. 2000: 43-4). Here, it was important to the community that the archaeologists establish their integrity, that they engendered trust, that they encouraged active participation in the project, especially by employing members of the community in the work, that they maintained a constant presence in the area, that they conveyed information to the community members in ways to which they could respond, and – as in Egypt – that locally-found archaeological material remained in the area. In both cases, these factors contributed to a sense among the local community of the project as something of direct relevance to them and in which they had a direct stake, both emotional and economic. It also engendered trust among them of the archaeological team, who arrived as strangers. In both cases, however, the community was involved by the researchers. A similar kind of project in Fiji (Crosby 2002) aimed to go a little beyond this by listing the requirements for a 'true' community archaeology project, which are said to be:

- initiation of the project by the local community
- a basis in local ideology and attitudes, linked to concerns for sustainable resource-use
- the provision of expert advice from outside the community
- external (in this case, government) funding.

Here, the community calls upon others to undertake the work, which is then organised and financed from outside. Although dependent upon the willingness of professional experts to place themselves at the service of untrained locals and of government agencies to provide full financial support, which may be exceptional and peculiar to the Fijian context, there is nevertheless an indication here of a way forward in terms of creating a viable common property regime for archaeology and which relates to transaction costs, to be discussed further below.

'Democratic' archaeology projects take a similar approach. At Sedgeford in England, for example, a local committee of trustees has control over the project as well as employing – indeed relying heavily upon – local labour, while hierarchical structures are minimal (Faulkner 2000: 31-2). In other cases, more formal structures serve to support community control. At the Levi Jordan Plantation site in Brazoria, Texas, USA (McDavid 1997; 1999; 2000; 2002; 2004) control over archaeological research and its public interpretation is in the hands of a board of trustees drawn from descendants of former owners of the plantation and those they enslaved and their representatives, the aim of archaeologists being to collaborate with members of local descendant communities in reciprocal, non-hierarchical, mutually empowering ways (McDavid 2000: 222). It is also clear, however, that any particular initiative requires the permission of the trustees, that committee members are involved in every stage of the project and are seen as the 'bosses' who direct the archaeologists; these are then concerned both to involve committee members, and to be 'involved in [committee members'] own agendas, according to ... mutual needs' (McDavid 2000: 222). Nevertheless, McDavid admits that the committee members perceive her as the project leader, a role she both claims and does not attempt to disguise (McDavid 2000: 222).

McDavid takes an explicit approach to her work at the Levi

Jordan site, grounded in American pragmatist philosophy, which entails the establishment of a continuing 'conversation' about issues at the site (McDavid 2000: 229; 2002: 305). She emphasises the diversity of backgrounds of committee members and of attitudes towards the site, both white and African-American, and draws upon the pragmatist approach as a way to accommodate this without closing the conversation. First, she notes how involving herself as one actor in a conversation among many served to enhance her standing in the community, rather than diminish it: effectively by denying her own 'expert' status as an archaeologist she was able to emerge as the community's expert (McDavid 2000: 230). Second, she sees how the abandonment of scholarly authority allowed her to engage more closely with the more contingent and contextual interpretations of others' lives by those others (McDavid 2000: 230-1). Thirdly, a pragmatic approach is about keeping the conversation going, not about winning arguments: accordingly, disagreements between actors become not problems to be overcome but opportunities to engage more deeply with colleagues (McDavid 2000: 231). The outcome is an approach grounded in four principles: reflexivity; multivocality; interactivity; and contextuality (McDavid 2002: 307-10) designed to maintain the conversation and by doing so to build trust with the community whose project it is.

None of the projects outlined here have described themselves in terms of property relations, although they may recognise that community 'ownership' in a broader sense (to be examined in the next chapter) is what they aim at. Nevertheless, as community projects they represent the rejection by professional archaeologists of any claim to exclusive control over the object of their research – archaeological material itself – or its products. As discussed in previous chapters, it is this right of use which constitutes a property right. To abandon it to others is therefore to abandon the claim to property. It is appropriate

89

therefore to consider these experiments in community archaeology also as experiments in the common ownership of archaeological material.

Assessing co-ownership in archaeology

Against Bromley's (1991: 3) criteria for evaluating the success of common property regimes, community archaeology projects such as those covered above appear to do well. In all cases, the resource – the site and its products from research – are not squandered: local involvement and leadership in the project ensures that the resource is given value; and where the project offers opportunities for local employment, this ensures further a direct economic incentive in preventing damage and looting. The resource is in various ways enhanced: by the process of research, it yields new information for archaeologists and others; outreach and educational programmes – for locals and others – ensure that this information is made widely available, while formal academic publications give the resource intellectual value; where recovered items are retained in a local museum, the nearby site from which they come is given greater prominence and the objects themselves are more closely contextualised. The lack of 'anarchy' among co-owners is attested by the continuing nature of these projects and their success in maintaining and enhancing the resource, as well as establishing and retaining good will among the local community.

It is perhaps less clear whether these projects comply with Ostrom's (1990: 211) suggestions for factors encouraging the inception of co-ownership schemes. There appears to be a shared appreciation among those involved as to the mutual benefits of working together: traditionally, archaeologists have been unwilling to engage with others in conducting research (see e.g. Skeates 2000; Smith 2004), and these projects overcome such disciplinary pride. Whether there is an expected

equality of outcomes is more difficult to assess: clearly the benefits for archaeologists are different from those of the local or descendant community; on the other hand, all receive benefits from a deeper understanding of that particular past, and both locals and archaeologists from outside will benefit from employment opportunities where these are part of the arrangement. Certainly, there seems to be a recognition that all will benefit, even where this is clearly in very different ways and possibly benefiting one group more than another, and this may be enough. It is also difficult to evaluate transaction costs: these may be low in certain cases, higher in others; overall, since the projects continue, they may be simply low enough (especially as compared with benefits received) for those involved; or, as will be suggested below, are covered by other means. Commentators on these projects all emphasise the importance of trust between archaeologists and the community, whether as an outcome of other aspects or as a key element to begin with: a preparedness to invest in the community, a clear and demonstrable willingness to defer to the community in decision-making, and ensuring a presence in the community outside of fieldwork periods are all important elements here. Numbers of co-owners vary: where an entire community is directly involved, numbers may be high; on the other hand the appointment of representatives to a managing committee will serve to limit interactions. It is evident, however, that this was the least important factor to emerge from Ostrom's analyses; the others are reasonably well met.

Ostrom's (1990) eight components for a successful common property arrangement are also generally well met. In all cases, the resource – a local site or the archaeology of a given area – is clearly defined. In most cases the purpose of the project – whether pure research into the past or to encourage tourism – is made clear. It is frequently the community who make the rules regarding how the project will be conducted, and accord-

ingly they will meet local needs and conditions, while there is also in all cases common agreement as to the rules and how they may be changed. Monitoring of the project is conducted jointly by archaeologists and community alike in both formal and informal ways: the peer-review process evident in formal academic archaeology serves to support such monitoring, as will auditing of financial and other arrangements. Sanctions for rule-breaking or failure to perform will be appropriate for the project and agreed by parties, and will involve external recognition of the arrangements in place. Whether dispute resolution is low-cost or otherwise will depend upon specific arrangements: like transaction costs generally, this is difficult to assess. In terms of archaeologist's time and effort, however, and the way in which this will inevitably impact upon their specifically archaeological performance, it will seem that these costs are quite high.

Such a point may appear to invalidate any argument made in favour of treating such projects as common property regimes. If such regimes rely for their success upon low transaction costs, then if these costs are high they do not meet suitable tests. A common factor in all the cases discussed above, however, has been a willingness on the part of those with a specifically non-economic interest to invest in the community project. McDavid (2000: 222) is recognised as a project leader and takes time and trouble to ensure community wishes are respected and disputes addressed. Moser and her colleagues (Moser et al. 2002) and Field and hers (Field at al. 2000) were at pains to build significant trust and willingness to collaborate among members of the communities they work with. In Fiji (Crosby 2002), government funding and the provision of expert guidance was a pre-requisite for the project.

In all these cases, the costs of establishing and maintaining community involvement may in fact have been very high: the same applies in the case of the Thanet example quoted by Cole

(2002: 127), where the burden was carried by English Nature. This may be the key to addressing this issue. It is not necessarily that overall transaction costs need to be kept low for environmental resources to be held as common property: but if one or more owners, or an agency acting on their behalf, is prepared to carry them on behalf of all, then they will be considered low so far as owners are concerned, allowing them to act as if transaction costs are in fact low. In the case of community archaeology projects, it is generally the archaeologists involved who are prepared to carry these costs – in terms of effort and time – on behalf of the owning community, of which they may also be members. Where it is a State agency that shoulders the cost – as in the case of English Nature or in Fiji – they do so without also appropriating the resource to themselves: this is different therefore from exclusive State ownership.

Creating a common property right in archaeology

Assessing community archaeology projects as if they are common property systems may be a useful academic exercise: but in practice – except in so far as such projects involve actual trusteeships and their formal incorporation as types of legal person, as at the Levi Jordan site (McDavid 1997; 1999; 2000; 2002; 2004) – they do not generally represent property ownership in the full legal sense. To achieve this, some form of specific property must be created and rights in it duly allocated.

Heritage as intellectual property

A problem with heritage that is frequently stated is that it does not, in fact, represent any kind of property (see e.g. O'Keefe and Prott 1992; Brown 2004; Rowlands 2004). A way of overcoming

this problem that has been proposed is to treat cultural re-sources as a form of intellectual property – akin to a copyright or a patent. The idea derives in particular from problems attendant upon the appropriation for commercial use of tradi-tional knowledges concerning especially the medicinal use of biological material. As justified by Ditchfield (2000: 15), recog-nising such knowledge as a form of intellectual property serves to privatise (and thus give a market value to) a common or open-access resource otherwise lacking such a value, and also acts as a market intervention to prevent abuse of those in a weak negotiating position. This view is supported by standard economic arguments that ownership of rights in a valuable property (knowledge) encourages trade in that property and provides an incentive to production, while increases in produc-tion contribute to an increase in general welfare. At the same time, the moral rightness of giving ownership rights is asserted, and of course such rights have the merit of general recognition.

The system of intellectual property ultimately recommended consists of:

- the grant of intellectual property rights to communities
- the explicit recognition of community and collective rights
- the recognition of sectional community rights – to protect the infringement of rights to hold sacred or special knowledge that may be part of the local culture
- comprehensive conservation legislation to protect the re-source from exploitation
- a public defender or ombudsman to advocate and protect the rights of the community (Ditchfield 2000: 79-81).

Here, legal ownership of a resource is vested in a recognisable community with clearly defined rights and with sufficient out-side investment – in the form of supporting legislation and a mediator – to keep transaction costs (at least for community

94

members) low. This way forward therefore meets Ostrom's (1990: 211) list of preconditions for a common property regime to become established.

It follows from this section and the last that if a given community was granted the right of ownership of an archaeological property under arrangements like these, and the archaeological project was then organised as a community archaeology project such as those discussed earlier, it would meet the conditions set by economists for a successful common property regime. The question remains, however, as to identify a given community as 'rightful' owners of the property.

Identifying co-owners: stakeholders in archaeology

It could be argued that major differences between divergent stakeholders in relation to archaeological remains represents just the state of 'anarchy' that Bromley (1991: 3) warns against in assessing the success or failure of common property regimes. On the other hand, so long as agreement as to the need to maintain the resource remains in place, and his other requirements (non-depletion of the resource and possible investment in it) are met, no such anarchy really exists. All that matters is that mechanisms are in place to regulate, negotiate and mitigate differences in use and access requirements among different categories of co-owner. In advocating what he calls 'the stakeholder society', political writer Will Hutton (1999: 85-96) offers seven principles for effective stakeholding, which can be conveniently adapted (and paraphrased) for application here:

- openness and democracy
- inclusion
- recognition that ownership confers duties as well as rights
- doing the right thing without policing

- recognition that economic entities are primarily social in nature
- that economic returns must also be shared
- recognition of the role of external institutions.

These principles amount to an effective programme for mutual co-operation among what may be very different interests, which is precisely what is required by a co-ownership arrangement for an environmental resource. They also map quite well onto McDavid's model of a 'democratic' archaeology (McDavid 2004) in that all serve to keep going the pragmatic 'conversation' that lies at the heart of such an idea (McDavid 2000).

The question that necessarily arises at this point, however, is to consider those who should be involved in such a conversation and to develop a list of those who can legitimately claim co-ownership of the archaeological resource. This list cannot consist of actual users only, as recognised by Cole (2002: 127), although his list of those involved in decision-making at Thanet appears to exclude some likely candidates. While hoteliers may profit from incoming tourism, for example, tourists themselves do not appear. Nor do other members of the local community who do not neatly fall into other categories already represented, such as dog-walkers or coastal navigators, or indeed those who merely live in or near the land affected by preservation efforts. Also excluded are potential interested parties, such as those who may wish to develop property or prevent such property development, utility companies and environmental protesters. Indeed, anyone can be proposed as a legitimate stakeholder who represents any potential for use of the resource in any manner: this would bring into the equation those who represent the non-use values recognised by Darvill (1995) and others as 'option' values and 'existence' values, which exist in potential but may never be realised.

Merriman's (2004) edited volume provides an attempt to

identify relevant stakeholders for the purposes of 'public archaeology'. These include the State (Thomas 2004), a rather ill-defined 'public' albeit in Brazil (Funari 2004), local communities (Mapenda and Lane 2004), indigenous peoples (Parker Pearson and Ramilisonina 2004; Byrne 2004), amateur and 'alternative' archaeologists (Schadla-Hall 2004), metal detectorists and treasure-hunters (Bland 2004), and antiquities dealers (Qin 2004). Others have generated similar lists, such as McManamon's (1991) comprising an unspecified 'general public', students and teachers, legislators, government officials and Native Americans. The problem with such generic lists is that they fail to specify who actual owners should be: it is clear that one of the elements for a common ownership regime is that ownership rights are limited to certain parties only; unlimited participation would take us into the realm of 'open resource' which (as will be discussed in the next chapter) is something different. Common ownership is not the exclusive ownership represented by private or State property regimes, but it is not entirely open either. Accordingly, to qualify, some limit must be placed upon candidacy; and also to meet Ostrom's (1990) criteria for successful common ownership arrangements.

One way is simply to recognise the manner in which this has already been addressed in community archaeology projects and in considering the grant of intellectual property rights to holders of traditional knowledge. In general, a community – whether defined geographically as 'local' or by affiliation as 'descendant' – can be considered to be self-defining in large measure. Once recognised, rights can be granted to the community as an entity in itself, leaving the community to decide rules of admission and exclusion, systems of representation, and the allocation of responsibilities and powers. This will necessarily exclude some actual and potential stakeholders, but this has not prevented success in other cases. Instead, the role of advocate for these other voices is vested in whatever other agency

takes on the responsibility for managing the system and carrying the transaction costs associated with the project. This – as in examples cited above – may be an individual such as Carol McDavid in the case of the Levi Jordan Plantation (McDavid 2000: 222), the State as in Fiji (Crosby 2002) or an organisation such as English Nature as at Thanet (Cole 2002: 127).

Conclusion: a common property regime for archaeology

This chapter breaks new ground for this book (and indeed the work of its author) in two ways: first by addressing ideas not previously approached from archaeology; and secondly by proposing actual recommendations. It would seem that the idea of archaeology as a form of common property may not be quite so outlandish as may be first thought, and indeed that there is a practical way in which it could be accomplished. This then is the proposal in outline:

- that archaeology – both as material in the ground and as practice – be treated as a form of intellectual property right (IPR)
- that a specific IPR in archaeology be granted to a given community
- that the community establish rules governing the management and conduct of archaeological research and related activities
- that the role of monitoring the project and acting as a locus for dispute settlement be placed either with the archaeologists involved, or outside the community altogether, thus reducing transaction costs for co-owners.

This extension of community archaeology into the realm of common property would overcome many of the problems iden-

tified with exclusive rights discussed in previous chapters. However, the idea of archaeology as any kind of property may yet be challenged: this takes us again further from exclusive claims and into the realm of the next chapter.

6

Archaeology as an
open-access resource

This book seeks to 'unpack' and de-naturalise the concept of 'cultural property', a term which – although widely used – has many critics. Jeanette Greenfield, among others, has usefully reviewed the use and meaning of alternative terms for the same body of material: she concentrates on 'cultural property', 'cultural object', 'cultural heritage', 'cultural relic' and 'cultural treasure' (Greenfield 1989: 252-5). While cultural property lawyers O'Keefe and Prott declared an early preference for the term 'cultural relic' (O'Keefe and Prott 1984), Greenfield prefers 'cultural treasure', and Norman Palmer and his associates prefer 'cultural property' for the title of their legally- and economically-inclined journal. These differences in choice of term relate to the intention behind the choice. Greenfield seeks to separate out specifically cultural *treasures* as constituting 'only exceptional or unique landmark objects' (Greenfield 1989: 255) because she seeks to determine legal criteria for the return of such objects to their original location; she accepts that such return can only ever be exceptional, and so only applies to exceptional items. O'Keefe and Prott (1984) are concerned to record the coverage of law of all components of the archaeological heritage, and thus seek a term for individual items that is as wide and (relatively) value-free as possible: for them, 'relic' is a term descriptive of the physical form of an item, not a value ascription; their more recent declaration is for 'cultural heri-

tage' as one encompassing the concerns of all interests in this area, in direct opposition to 'cultural property' (O'Keefe and Prott 1992).

Greenfield concentrates her discussion on the notion of the object as representative of 'culture'. She focuses in particular on the broad usage of the term, comprising as it does 'both the *Mona Lisa* and a photograph of the living room of a French steelworker' (Greenfield 1989: 252), although citing with ironic disdain O'Keefe and Prott's (1984: 33) extension of the concept of 'cultural heritage' to include human faeces (Greenfield 1989: 255) despite the fact that from a strictly archaeological perspective such remains can be of immense value in understanding the past. She goes on to point out that in the other half of the 'cultural property' equation, the term ' "Property" is ... used in a legalistic sense to denote ownership' (Greenfield 1989: 255) and it is on this aspect that Palmer and his associates have tended to concentrate. The opening issue of *The International Journal of Cultural Property* set out the concerns of the field, relating to 'questions of cultural property policy, ethics, economics and law' (Palmer 1992: 5), 'transactions' (Palmer 1992: 6) and the 'authenticity' of individual pieces (Palmer 1992: 7). Their choice of term and the approach it represents is open to challenge from the legal community as well as the archaeological (O'Keefe and Prott 1992). Much of this discussion remains at the level of criticism of the term itself, however: it will be evident that this book seeks to go beyond the critique of particular choices of terminology to the concepts which lie behind the choice.

Some recent anthropological writing takes us beyond this concern with mere words to the substance of property relations and their application (e.g. Verdery and Humphrey 2004). Michael Brown's (2004: 51) attack on creating intellectual property rights in culture begins by pointing out that the association of the concept of 'culture' with specific and bounded

communities is contrary to anthropological use (see e.g. Fox and King 2002; Kuper 1999). He goes on to challenge the notion of 'cultural property' on the grounds that it serves to reify culture as a concept and also to increasingly identify it with specific property (Brown 2004: 52). A similar argument is used by Michael Rowlands (2004) in the same volume, who asserts that in practice 'the contrast between rainforest conservation, indigeneity, and the transmission of grievance could not be greater, but at another more abstract level, these shade into each other as part of the struggle for existence in the twenty-first century' (Rowlands 2004: 223) since they are jointly mobilised to defend traditional ways of life. Accordingly, he argues, claims for recognition of rights in cultural property – although at variance with the phenomenon of culture itself – are at least inevitable if not necessary. Such arguments are useful in raising objections to the spread of the idea of exclusive claims to cultural material, but fail to provide practical alternatives to the application of ideas about property. In part, this must be because of a general lack of models on which to draw: the literature of how to construct a non-property regime is thin to non-existent.

Voluntary restraint

This is not to say that alternative approaches are not available: it is simply that they have not generally been considered as models of regimes applicable to the management of environmental resources such as archaeology. In terms of the conservation of such resources and the avoidance of their over-use, this implies a degree of restraint on use. Normally, this will be achieved by the allocation of property rights which serve to exclude from access and use those not granted such rights. For this chapter, however, we abandon such an approach and must look elsewhere for advice and inspiration.

Anarchist communism

The anarchist ideas about property introduced in Chapter 2 especially re-emerge here. Although designed to replace ownership in its relation to economic production, they may nevertheless be able to point us in appropriate directions despite the fact that in general they map quite effectively onto property regimes we have already identified in Chapters 3 and 4 (Table 6.1). Godwin's individualist holds to a form of private right in property, while Proudhon's mutualism is akin to a form of institutional ownership on behalf of a collectivity. Since anarchists reject the State they offer no equivalent to State ownership, but Bakunin's collectivist ideas are close to a form of common property arrangement as discussed in the last chapter. In contrast to these, Kropotkin's communism represents access to everything for all regardless of status; this is the closest idea anarchists have to a form of open-access or non-property arrangement.

Table 6.1. Current heritage property relations and anarchist alternatives

Current property type	Anarchist alternative
Private	Individualist
Institutional	Mutualist
State	(None)
Common	Collectivist
Open access	Communist

In a series of works spread over his life, Peter Kropotkin sought to justify and outline his anarchist vision of an alternative to the State and capitalist private ownership. In his book

Mutual Aid (Kropotkin 1972b), first published in 1902, he extols in particular the free medieval city and its structure based upon the craft guild. These he envisions as free associations of workers, bound together by mutual responsibilities and duties. He points out, however, that an organisation grounded in economic production did not ignore the needs of its members as consumers: to provide for ' "the common first food and lodging of poor and rich alike" ... was the fundamental principle in each city' (Kropotkin 1972b: 162). Accordingly, no private retailer of staples was allowed access to deliveries until the city administration and then its citizens had first had an opportunity to meet their own needs (Kropotkin 1972b: 162-5). As Kropotkin sums it up, the medieval city

> was not simply a political organisation for the protection of certain political liberties. It was an attempt at organizing ... a close union for mutual aid and support, for consumption and production, and for social life altogether ... giving full liberty of expression to the creative genius of ... individuals (Kropotkin 1972b: 165-6).

He lists also the continuation of the co-operative principle into the modern world: the existence of 'friendly societies, the unities of odd-fellows, the village and town clubs organised for meeting doctors' bills, the dress and burial clubs' (Kropotkin 1972b: 232), together with entirely voluntary organisations such as the Lifeboat Association in the UK, mine rescue teams, and charitable and educational associations across Europe (Kropotkin 1972b: 232-8). Elsewhere, in the same vein, he quotes the examples of the European railway network (Kropotkin 1972a: 146-51) and the Red Cross organisation (Kropotkin 1972a: 155-7). The emphasis here is upon the provision of aid, support and resources for others without any claim on or need for reimbursement: whatever time, effort and money may be

required for the purpose is provided free and without restraint. It is the anarchist communist vision that this willingness to work for others without return can be extended to cover all of life:

> when the instruments of production are placed at the service of all ... when labour, having recovered its place of honour in society, produces much more than is necessary to all – how can we doubt that this force (already so powerful) will enlarge its sphere of action till it becomes the ruling principle of social life? (Kropotkin 1972a: 65).

Whatever the historical, economic and sociological truth of Kropotkin's vision, which may indeed be flawed in terms of historical specifics, the point here is that it represents a way of envisioning the role of economic resources without the need for specific ownership. Instead, the claim to access is based not upon exclusive rights but upon need or even desire: Kropotkin's unqualified slogan from 1906 is 'well-being for all' (Kropotkin 1972a: 51), grounded in the availability of uncounted riches. Archaeology too constitutes part of this collective stock of wealth:

> For thousands of years millions of men have laboured to clear the forests, to drain the marshes, and to open up the highways by land and water. Every rood of soil we culti-vate ... has been watered by the sweat of several races of men The cities ... are organisms which have lived through centuries. Dig beneath them and you find one above another, the foundations of streets, of houses, of theatres, of public buildings. Search into their history and you will see how the civilisation of the town, its industry, its special characteristics, have slowly grown and ripened through the cooperation of generations of its inhabitants

before it could become what it is today Millions of
human beings have laboured to create this civilization on
which we pride ourselves (Kropotkin 1972a: 44).

Accordingly, human beings are allowed a right to luxuries as
well as the staples of existence; accordingly 'after bread has
been secured, leisure is the supreme aim' (Kropotkin 1972a:
124). This is not a leisure spent in idleness, however, since
people do not choose to languish all their hours away. Instead,
the citizen of the anarchist communist world 'will discharge
first his [limited time of working] in the field, the factory, and
so on, which he owes to society as his contribution to the general
production [of more than enough for all]. And he will employ the
second half of his day, his week, or his year, to satisfy his
artistic or scientific needs, or his hobbies' (Kropotkin 1972a:
127).

The result foreseen is 'a society in which – all having become
producers, all having received an education that enables them
to cultivate science or art, and all having leisure to do so – men
would combine to publish the works of their choice, by contrib-
uting each to his share of manual work' (Kropotkin 1972a: 129).
The effects on environmental matters is direct: Kropotkin
(1972a: 129) envisages tens of thousands contributing to sub-
jects such as geology, rather than the paltry few with education
and leisure enough to pursue it in his own day. Beyond this,
there is an interest in his work in what today we would call
'sustainable' development: especially in his 1899 book *Fields,
Factories and Workshops Tomorrow* (Kropotkin 1974) where
the author challenges some of the basic tenets of capitalist (and
indeed Marxist) economics. His first target is the principle of
the division of labour into specialist castes, and instead he
offers *'integration of labour'* (Kropotkin 1974: 26) whereby all
have the opportunity to contribute to all aspects of life. He goes
on to challenge the growth of industry into larger and larger

units and the drive to meet the export trade, in favour of smaller units of production for home consumption (Kropotkin 1974: 27-40 and 121-58) and small-scale agricultural production (Kropotkin 1974: 47-107). These ideas derive in particular from an understanding of economics as 'the study of the needs of men and the means of satisfying them with the least possible waste of energy' and other resources (Kropotkin 1974: 17). Accordingly, he sees the rise of large-scale industry and industrial-scale agriculture as a contradiction to this principle.

At root, Kropotkin's ideas are based upon two key assumptions. The first is that there are indeed sufficient resources available in the world – natural, technical and human – to supply all of humanity with all they could possibly need. The second is that once this is recognised, that any drive to the private or exclusive appropriation of resources will be replaced by a common willingness to allow others access to available resources whatever their form. In other words, that once it can be seen that one's needs and desires can be satisfied, then a form of voluntary restraint will be exercised that will allow everyone the same access to whatever they need. Such beliefs are in direct contrast to the claims of archaeologists to stewardship of the archaeological resource (see e.g. Smith 2004: 81-104), arguments in favour of State ownership of archaeological resources (e.g. Renfrew 2000) or arguments for private ownership as a protection against nationalist and retentionist policies (e.g. Merryman 1989).

Non-property objects: the case of the moon and stars

In case it is thought that this book ultimately relies on a kind of 'pie-in-the-sky' impractical dreaming to satisfy its objectives, it is worth pointing out that there is in existence at least one clear arrangement for the non-ownership of an environmental

resource to which all countries in the world have agreed. The 1967 Treaty on Principles Governing the Activities of States in the Exploration and Use of Outer Space, Including the Moon and Other Celestial Bodies (text at: www.state.gov./t/ ac/trt/5181.html) specifically bans the appropriation by any state for its exclusive right of any object in outer space (Article II): by Article VI the responsibility for compliance is extended below the level of the nation state, to state agencies, corporations and citizens alike. The specifics are technical matters of legal interpretation, but the intention is clear enough: that the moon, the stars, the sun and the rest of the universe are not to be subject to exclusive ownership. Indeed as Article I states, 'Outer space, including the moon and other celestial bodies, shall be free for exploration and use by all States without discrimination of any kind, on a basis of equality ... and there shall be free access to all areas of celestial bodies.'

That the moon and stars represent an environmental resource of the kind considered here will be evident. In many ways the moon is a classic 'heritage' object: it has a long history and carries many meanings to many different kinds of people all over the globe. Its light – which waxes and wanes interestingly – shines over the entire inhabited world. The pull of its gravity regulates the ocean tides and therefore many kinds of cultural and economic activity related to them. In modern western culture it has become iconic of romantic attachment, and in other cultures is and has been the object of religious devotion. Together with the sun, other planets and the stars it represents the inhabitants of the night sky, and all have been included in systems of prophecy and divination for centuries. It is an object of intense scientific study and became a part of human geography as a result of a series of landings by astronauts from 1969 into the 1970s: live broadcasts of these events were seen by television viewers all over the world. Although humans no longer walk regularly on the surface of the moon,

they continue to inhabit an international space station and ongoing research has led to the deposit of human-made material across the solar system and beyond. Outer space is accordingly seen as a resource with many uses.

The treaty provides exactly the kind of free access to the resources of outer space envisaged by anarchist communism for any resource. The treaty forbids the claiming of any part of outer space as national territory or – by extension to 'national activities' (Article VI) – for exclusive use or as private property. But it also makes no provision for the allocation of property rights in outer space to any international or other agency to hold on behalf of humanity. By doing this, outer space remains outside the realm of property relations. The danger of becoming subject to the 'tragedy of the commons' (see Chapter 2) is instead met by a common agreement not to use rights of access in such a way as to interfere with the rights of access of other potential users. In practice, of course, only a limited number of States have the resources to explore beyond the Earth, and fewer private individuals or corporations: and not all who could actually wish to. Accordingly, it costs little to conform to the conditions of such an agreement. The practicality of these provisions, however, is not really the issue here: the point is that those who suggest that environmental resources inevitably require protection from abuse and destruction by the allocation of property rights in some form – whether to private agencies, to the State, or to agencies of custodianship or stewardship – can be referred to the Outer Space Treaty as an example of an alternative approach.

As with Kropotkin's vision, a form of voluntary restraint is all that is required to protect environmental resources from harm. This derives from a recognition that there is enough of a particular resource for all to benefit without the need for its division among specific individuals. Instead, all that is required is that those with an interest or need take from it no more than

they require and leave the rest alone. What remains is to consider where such a recognition of the extent of the resource derives from, and how it can be seen as a resource that can be used by many – or all – and yet retained for future use.

Cognitive ownership

The key entry to an understanding of how the nations of the world could agree to desist from carving outer space up among themselves (rather as the European states did to Africa in 1880) comes from the preamble to the Outer Space Treaty, which calls upon signatories to assert that they:

- recognise 'the common interest of all [humankind] in the progress of the exploration and use of outer space for peaceful purposes'
- and believe 'that the exploration and use of outer space should be carried on for the benefit of all peoples irrespective of the degree of their economic or scientific development' (www.state.gov./t/ac/trt/5181.html).

Here, that common interest and recognition of benefits to all gives rise to a willingness to restrain from appropriation. It is an example of what has been termed 'cognitive ownership' (Boyd et al. 1996), which is defined as 'the interest in or association with a cultural site claimed, even implicitly, by any person or group who attaches some value to that place' (Boyd et al. 2005: 93). Such interests and associations – as discussed in relation to common ownership in Chapter 5 – are variable, and may be economic, intellectual, spiritual or conceptual, among others. As Boyd and his colleagues put it, 'for every place a wide range of "owners" and meanings can be identified, each with particular relationships with the place [or object] and, importantly, with every other owner' (Boyd et al. 2005: 93).

111

Chapter 3 referred to the two opposed models whereby value is connected to treatment: that values determine the treatment of an object to which those values adhere (e.g. Lipe 1984); and the idea that by treating objects in a certain way, they are ascribed certain types of value (e.g. Carman 1996b). For the purposes of that stage of the argument, it did not matter which of the two models was adopted: each indicated the close connection between values and ownership regimes. Here, however, one model will dominate: the application of ideas about cognitive ownership (Boyd et al. 2005) has led researchers to see the process of value formation as one closely tied to academic and professional interest in a site or place; in other words, that by treating objects in certain ways, they gained an increasing and more complex set of values. This is a model of value I have applied elsewhere, derived from especially the work of Michael Thompson (1979; Schwarz and Thompson 1990). As I put it then: you start with a socially induced predilection that leads you to favour the sort of social arrangements promised by protecting particular classes of material; and having chosen you then look around for ways to value that class of material over others (Carman 1996b: 31). This is the process that leads in particular – but not exclusively – to the legal protection of ancient remains and its management as a 'public' good. Archaeological material achieves this public status not out of some inherent quality in the object itself, but by dint of becoming an object of legal attention. By granting legal status, however, responsibility is passed to a recognised agency: such laws thus become the mechanism by which rights of ownership and control are appropriated to empowered agencies. The material thereby becomes a body of 'cultural property'. However, the process can also be re-appropriated for the purpose of denying cultural property status.

In a series of case studies, Boyd et al. (2005: 98-107) indicate the processes by which professional interest in sites in Austra-

lia engendered the development of local interests and values built around differing attributes. Accordingly, they show how local Aboriginal interests mostly focused upon sites representing indigenous and traditional attitudes to land and environment, or to the history of their engagement with incoming colonisers. European Australians also recognised such claims and the sometimes spiritual dimension these indicate. Others however were more concerned with current social and economic uses – as tourist sites, recreational space, or thoroughfares – although not all of these conflicted with Aboriginal conceptions: the attitude of skateboarders to a rock-art site, for instance, could be seen as another example of significance to a particular subculture (Boyd et al. 2005: 107). It was by raising questions about such places that values were ascribed and which marked their importance to inhabitants of the locality and beyond. The same set of processes was evident at the Hilton of Cadboll site in Scotland (Jones 2004). Here, excavation of the lower portion of an inscribed Pictish stone and its reconstruction ignited controversy over the ownership and placement of the reunited object, which was claimed both by the national museum in Edinburgh and the locality. Investigation of the contexts within which contemporary meanings for the stone are created identified a complex set of interlocking values. Academic and intellectual values included those of archaeology, art history, folklore and oral history (Jones 2004: 27-33). In parallel to these, there was a more symbolic sense of its identity, as a living part of the community, and as an object 'born' into the locality (Jones 2004: 33-7). As such it at once belongs to the community, is part of it and also constitutive of it: 'as well as being conceived of as a living member of the community, the monument is also simultaneously an icon for the [community] as a whole' (Jones 2004: 37). This extends into the monument's role in the construction of a sense of place, and indeed of reforging a 'lost' sense of community cohesion (Jones 2004: 39)

that can be 'healed' (at least symbolically) by reuniting the two original pieces of the monument.

Ideas about cognitive ownership inevitably relate closely to issues of 'social value'. These are a measure of 'collective attachment to place', and places where this is evident have been conveniently defined by work in Australia (Johnston 1994) as those which:

- provide a sense of connection with the past
- tie the past affectionately to the present
- provide an essential reference point in a community's identity or sense of itself
- help give a disempowered group back its history
- provide a sense of collective attachment to place
- 'loom large in the daily comings and goings of life' and are 'places where people gather' (Johnston 1994: 7).

Sites such as Hilton of Cadboll (Jones 2004) and those cited by Boyd et al. (2005) clearly fall within this category. It is clear that the kinds of values that are ascribed to such places are multiple and can be conflicting: but at the same time none prevent the ascription of other values to the same object at the same time. Accordingly, intellectual and academic values can sit alongside popular, economic, recreational and tourist values. This is not to say that such an approach to value does not have its flaws. In particular, as is evident from any such study, there is a close reliance on anecdotal responses and on personal memory. This leads to a focus on the very recent past, even though issues may relate to an ancient place or object: it is the relationship of that place or object to the experience of those currently living which is assessed. This in turn leads to a tendency to place emphasis on places with positive values rather than those that are 'taboo' or have left darker memories or are bypassed or ignored. Overall, in terms of understanding

community, there is a tendency to seek evidence of community unity rather than disharmony: although in particular Jones (2004: 23-5) addresses issues of social inclusion and exclusion in relation to the Hilton stone, she also reports that 'these positions [of difference] and their relation to a hierarchy of knowledge were accepted, as those involved, broadly speaking, participate in a shared discourse' and that 'incomers [to the community] would acknowledge the authenticity and authority of the core of the community' (Jones 2004: 37).

Despite these misgivings about 'social value' as a category of analysis, however, it is evident that 'cognitive ownership' allows each claimant to a resource full access to it without interference from or interfering with access by others. By giving full reign to such cognitive claims, each can take from the resource without placing any restraint upon similar taking by others. It is not so much of a stretch from here to exercising a voluntary physical restraint on actual use of the resource so as not to deny it to others.

Conclusion: keeping while giving

The concept of 'keeping while giving' is well established in anthropology (see e.g. Weiner 1992). Choosing to exercise restraint on one's own use of a resource does not serve to deny it completely: but it does create the conditions under which others may have access to it as well. We have seen in this chapter that the idea of voluntary restraint on use is not as alien to Western thought as some students of economics would suggest: it is at the core of revolutionary anarchist thinking; and has been applied in the international sphere to protect outer space and its contents from appropriation. At the core of such treatments of resources lie two ideas: that there is enough of it to go around, and recognition that your use of it does not infringe my enjoy-

ment of it, even if they represent different kinds of use altogether.

In the case of the archaeological heritage, initial notice taken by professionals may serve to awaken interest in a local or wider community such that a range of different values and uses for the object become evident: in this case, 'cognitive ownership' can be claimed by all without any loss of the resource. Once this has happened, the conditions are met for voluntary restraints on actual use to be applied without the need for the allocation of specific property rights. Since the value of the object or place has been increased, and new ones ascribed, it becomes an object or place of significance to all its cognitive owners: none has an interest in its depletion or destruction. No agency need appropriate use rights in order to deny them to others; and no rights of access need be controlled by a custodian or steward. Here is the ultimate link between value and property asserted at the opening of this book: when the value is a social value held by all, then to conserve the resource no one need be granted any right of ownership.

7

Conclusions

The purpose of this short book has been to make a connection between two separate realms: ideas about property relations, and ideas about archaeological material, using the discourse of value as it has developed in archaeological heritage management as a linking device. The aim has been to present a direct challenge to the concept of 'cultural property' so blithely accepted by the archaeological community, which among other consequences – as argued in Chapter 1 – has caused us to disempower ourselves in relation to others with an interest in managing and controlling cultural objects. While Chapter 2 outlined some basic ideas about property relations, the value schemes outlined in Chapter 3 each imply (and even assume) a particular kind of property regime to be appropriate for ancient remains. Moreover, each value scheme was seen to be at once appropriate for particular kinds of agent and attaching itself to a particular kind of material (as indicated in Table 7.1 overleaf).

Here, each of the three main columns covers a particular category of object, showing its distinctive characteristics, and at the foot the value realm and property regime most appropriate to it (see also Carman 1998; 2002: 30-57). The leftward column concerns movable objects: no matter where it is or how long it stays there it remains identifiable as a particular kind of object; and the value realm is that of exclusive property rights. The central column concerns sites and monuments: these are fixed in space and can be distinguished from their surroundings by having boundaries placed around them; the

Table 7.1. Objects of heritage: categories defining various types of heritage object

Realm of the discrete		*Realm of the connected*
Object	Site & monument	Landscape
Mobile, but remains always 'itself': 'solid'	Fixed in space: 'bounded'	Extensive: 'unbounded'; changes over time
Object of property: exclusive ownership	Subject to custodianship: controls on use	Cannot be owned nor controlled: a product of modern *gaze* dependant on point of view

value realm is one of control on use rather than change of ownership. The third column concerns landscapes, which are not single things which can have a boundary placed around them: they are extensive and fill the space between other things. That is why the landscape in particular is something different from other categories of thing. Strictly speaking, it may not constitute a *thing* at all. Objects and sites or monuments are discrete, separable and identifiable single things: the landscape is the set of relationships that gives them their separateness. The conceptual gap between the discrete thing and the landscape is an unbridgeable one: they exist in separate conceptual realms. Here I call these *the realm of the discrete* (for objects and sites and monuments) and *the realm of the connected* (for the landscape). Since the landscape (as opposed merely to an area of land) is dependent upon the position of the

observer, it cannot be owned in the conventional sense. This opens up the possibility of seeking out alternative kinds of property relation for heritage objects, which was the purpose of Chapters 4 to 6.

Along the way, a number of alternative types of ownership were identified as relevant to heritage objects, and their consequences for those objects outlined (summarised in Table 7.2). The main consequence of private ownership is inevitably an exclusive right of access and use attached to the owner. The same in practice tends to apply in the cases of State ownership and ownership vested in an institution such as a museum or heritage preservation body. Access is limited by the State, usually to those persons authorised to act on its behalf. The purpose of museums and similar organisations is the preservation of heritage material, and this is most commonly achieved by placing restrictions on access: the placing of objects in museum cases, for example, or by placing barriers around landscape features. The application of these restrictions on access are frequently justified by the need to preserve the object or place from damage, but by this means ownership of the object is at the same time removed from those people and communities who lay claim to it as their heritage. As discussed in Chapter 3, the underlying value scheme for such treatment is economic, resulting in either a financial measure of value or one grounded in ideas about functional utility (and see also Carman 2002: 149-67; 2005: 48-51). The net result is to treat heritage objects and places as resources subject to conflicting uses and potential overuse.

It is perhaps a paradox that one of the alternatives to exclusive rights advocated in Chapter 5 provides exactly the same type and degree of protection as the allocation of exclusive ownership rights but grounded in an entirely different value system. A system of common ownership provides for restrictions on access and use but without the need for someone other

Table 7.2. Consequences for heritage under particular property regimes

Property type	Consequences for the heritage
Private	Exclusive access and use
State	Closed access
Institutional	Preservation by limitations on access
Communal	Preservation by limitations on access and use
Open access / non-property	No control – use to destruction *or* Recognition of social value

than those to whom the object or site has meaning appropriating its ownership. A paradox – or perhaps a dilemma to be resolved by experiment – is also evident in the case of a non-property or open-access regime. One argument – the one most commonly adopted by economists and lawyers who argue for the benefits of property rights – is that providing no restrictions on access to heritage objects will bring about its destruction by the workings of the 'tragedy of the commons'. In Chapters 2 and 6, however, alternatives to this outcome were put forward: either a system of common ownership, or more radically the recognition that allocating property rights served to deny the ascription of new values to the object. By allowing the growth of multiple systems of 'cognitive ownership' in relation to a heritage place, the enhanced value given that place led to its protection by very different 'owners' even though their own values were potentially in conflict. In other words, simply by marking the place as culturally important, it grew in social worth. The value scheme in operation here is the 'social' scheme

outlined in Chapter 3 (and see also Carman 2002: 167-75; 2005: 51-3), whereby heritage objects and places are raised out of the realm of resource use and utilitarian understanding into a cognitive space from which it 'speaks' to multiple owners of issues that matter to them.

In general, both systems of common ownership and open access have been denied a place in discussions about the management of the archaeological heritage. Instead, we have allowed the domination of a 'resource' model that inevitably leads to the adoption of an 'economic' understanding of heritage management issues. It is clear from Chapters 5 and 6, however, that viable alternatives are available: some are already in operation, albeit unrecognised for what they are; others may represent more risky endeavours but may be worth the trouble to try. For my own part, it seems to me that heritage objects and places – among them various kinds of archaeological object, site and monument, or landscape – are an ideal body of material on which to try radical ideas about property relations. I can think of few (if any) archaeologists who do not subscribe to the view that ours is a public endeavour carried out for the general good and that the past belongs to all: it may be time to put these beliefs into operation by finding alternatives to the ownership of such material. This book offers some initial ideas as to how to proceed: let us try.

Bibliography

Australian Accounting Research Foundation (AARF) (1993 revised 1996) *Australian Accounting Standard 29: financial reporting by government departments*. Melbourne: AARF.

Australian Accounting Research Foundation (AARF) (1995) *Statement of Accounting Concepts 4: definition and recognition of the elements of financial statements*. Melbourne: AARF.

Appadurai, A. (1986) 'Introduction: commodities and the politics of value', in Appadurai, A. (ed.) *The Social Life of Things: commodities in cultural perspective*. Cambridge: Cambridge University Press, 3-63.

Ashley-Smith, J. (n.d.) 'The ethics of conservation', *The Conservator* 6, 1-5.

Backschieder, P. and Dykstal, T. (eds) (1996) *The Intersections of the Public and Private Spheres in Early Modern England*. London: Frank Cass.

Balaam, N. and Rackham, J. (eds) (1992) *Issues in Environmental Archaeology*. Papers from the 10th Anniversary Conference of the Association for Environmental Archaeology held at the Institute of Archaeology, UCL, London, July 1989. London: UCL.

Baudrillard, J. (1975) *The Mirror of Production*. Trans. M. Poster. St. Louis: Telos Press.

Baudrillard, J. (1981) *For a Critique of the Political Economy of the Sign*. Trans. C. Levin. St. Louis: Telos Press.

Benn, S.I. and Gaus, G.F. (1983a) 'The liberal conception of the public and the private', in Benn, S.I. and Gaus, G.F. (eds) *Public and Private in Social Life*. London: Croom Helm, 31-65.

Benn, S.I. and Gaus, G.F. (1983b) 'The public and the private: concepts and action', in Benn, S.I. and Gaus, G.F. (eds) *Public and Private in Social Life*. London: Croom Helm, 3-27.

Berger, P. (1973) *The Homeless Mind*. Harmondsworth: Penguin.

Berkes, F. (1992) 'Success and failure in marine coastal fisheries of

Turkey', in Bromley, D.W. (ed.) *Making the Commons Work*. San Francisco: Institute for Contemporary Studies, 161-82.

Bland, R. (2004) 'The Treasure Act and the Portable Antiquities Scheme: a case study in developing public archaeology', in Merriman, N. (ed.) *Public Archaeology*. London: Routledge, 272-91.

Bold, J. and Chaney, E. (eds) (1993) *English Architecture: public and private: essays for Kerry Downes*. London: Hambledon Press.

Boniface, P. and Fowler, P.J. (1993) *Heritage and Tourism in 'the Global Village'*. London: Routledge.

Bourdieu, P. (1984) *Distinction: a social critique of the judgment of taste*. London: RKP.

Boyd, W.E., Cotter, M.M., O'Connor, W. and Sattler, D. (1996) 'Cognitive ownership of heritage places: social construction and cultural heritage management', *Tempus* 6, 123-40.

Boyd, W.E., Cotter, M.M., Gardiner, J. and Taylor, G. (2005) ' "Rigidity and a changing order ... disorder, degeneracy and daemonic repetition": fluidity of cultural values and cultural heritage management', in Mathers, C., Darvill, T. and Little, B.J. (eds) *Heritage of Value, Archaeology of Renown: reshaping archaeological assessment and significance*. Gainesville: University Press of Florida, 43-57.

Boyden, S. (1987) *Western Civilisation in Biological Perspective: patterns in biohistory*. Oxford: Clarendon.

Boyden, S. (1992) *Biohistory: the interplay between society and the biosphere – past and present*. Paris: UNESCO.

Brodie, N., Doole, J. and Watson, P. (2000) *Stealing History*. Cambridge: The McDonald Institute for Archaeological Research. http://www.mcdonald.cam.ac.uk/IARC/iarc/illicit_trade.pdf

Brodie, N., Doole, J. and Renfrew, C. (eds) (2001) *Trade in Illicit Antiquities: the destruction of the world's archaeological heritage*. Cambridge: McDonald Institute for Archaeological Research.

Brodie, N. and Tubb, K. (eds) (2002) *Illicit Antiquities: the theft of culture and the extinction of archaeology*. London: Routledge.

Bromley, D.W. (1991) *Environment and Economy: property rights and public policy*. Oxford: Basil Blackwell.

Brown, G.M. (1990) 'Valuation of genetic resources', in Orians, G.H., Kunin, W.E., and Swierzbinski, J.E. (eds) *The Preservation and Valuation of Biological Resources*. Seattle and London: University of Washington Press, 203-45.

Brown, M.F. (2003) *Who Owns Native Culture?* Cambridge MA: Harvard University Press.

Brown, M.F. (2004) 'Heritage as property', in Verdery, K. and Hum-

phrey, C. (eds) *Property in Question: value transformations in the global economy*. Wenner-Gren International Symposia Series. Oxford: Berg, 49-68.

Briuer, F.L. and Mathers, W. (1996) *Trends and Patterns in Cultural Resource Significance: an historical perspective and annotated bibliography*. Alexandria: US Army Corps of Engineers.

Butzer, K.W. (1982) *Archaeology as Human Ecology: method and theory for a contextual approach*. Cambridge: Cambridge University Press.

Byrne, D. (1991) 'Western hegemony in archaeological heritage management', *History and Anthropology* 5, 269-76.

Byrne, D. (2004) 'Archaeology in reverse: the flow of Aboriginal people and their remains through the space of New South Wales', in Merriman, N. (ed.) *Public Archaeology*. London: Routledge, 240-54.

Cahill, T. (1989) 'Cooperation and anarchism: a contemporary perspective', in Goodway, D. (ed.) *For Anarchism: history, theory and practice*. History Workshop Series. London: Routledge, 235-58.

Campbell, B.M.S. and Godoy, R.A. (1992) 'Common field agriculture: the Andes and medieval England compared', in Bromley, D.W. (ed.) *Making the Commons Work*. San Francisco: Institute for Contemporary Studies, 99-127.

Cannon-Brookes, P. (1994) 'Antiquities in the market-place: placing a price on documentation', *Antiquity* 68, 349-50.

Carman, J. (1990) 'Commodities, rubbish and treasure: valuing archaeological objects', *Archaeological Review from Cambridge* 9.2: 195-207.

Carman, J. (1995a) 'The importance of things: archaeology and the law', in Cooper, M., Firth, A., Carman, J. and Wheatley, D. (eds) *Managing Archaeology*. London: Routledge, 19-32.

Carman, J. (1995b) 'Interpretation, writing and presenting the past', in Hodder, I., Shanks, M., Alexandri, A., Buchli, V., Carman, J., Last, J. and Lucas, G. (eds) *Interpreting Archaeology: finding meaning in the past*. London: Routledge, 95-9.

Carman, J. (1996a) 'Data for the future or an amenity for the present: the values of the historic and natural wetland environment', in Cox, M., Straker, V. and Taylor, D. (eds) *Wetlands Archaeology and Nature Conservation*. London: HMSO, 18-29.

Carman, J. (1996b) *Valuing Ancient Things: archaeology and law*, London: Leicester University Press.

Carman, J. (1998) 'Object values: landscapes and their contents', in Rotherham, I. and Jones, M. (eds) *Conference Proceedings: 'Land-*

scape perception, recognition and management: reconciling the impossible', Sheffield, 2-4 April 1996. *Landscape Archaeology and Ecology* 3, 31-4.

Carman, J. (2000) 'Theorizing the practice of archaeological heritage management', *Archaeologia Polona* 38, 5-21.

Carman, J. (2002) *Archaeology and Heritage: an introduction*. London and New York: Continuum.

Carman, J. (2005) 'Good citizens and sound economics: the trajectory of archaeology in Britain from "heritage" to "resource"', in Mathers, C., Darvill, T. and Little, B.J. (eds) *Heritage of Value, Archaeology of Renown: reshaping archaeological assessment and significance.* Gainesville: University Press of Florida, 43-57.

Carman, J., Carnegie, G.D. and Wolnizer, P. (1999) 'Is archaeological value an accounting matter?', *Antiquity* 73, 143-8.

Carmichael, D.L., Hubert, J., Reeves, B. and Schanche, A. (eds) (1994) *Sacred Sites, Sacred Places.* London: Routledge.

Carnegie, G.D. and Wolnizer, P.M. (1995) 'The financial value of cultural, heritage and scientific collections: an accounting fiction', *Australian Accounting Review* 5.1, 31-47.

Carnegie, G.D. and Wolnizer, P.M. (1996) 'Enabling accountability in museums', *Museum Management and Curatorship* 15.4, 371-86.

Carnegie, G.D. and Wolnizer, P.M. (1999) 'Unravelling the rhetoric about the financial reporting of public collections as assets: a response to Micallef and Peirson', *Australian Accounting Review* 9.1, 16-21.

Carter, A. (1989) *The Philosophical Foundations of Property Rights.* Hemel Hempstead: Harvester Wheatsheaf.

Carver, M. (1996) 'On archaeological value', *Antiquity* 70, 45-56.

Cleere, H.F. (ed.) (1984a) *Approaches to the Archaeological Heritage.* Cambridge: Cambridge University Press.

Cleere, H.F. (1984b) 'Great Britain', in Cleere, H.F. (ed.) *Approaches to the Archaeological Heritage.* Cambridge: Cambridge University Press, 54-62.

Cleere, H.F. (1984c) 'World cultural resource management: problems and perspectives', in Cleere, H.F. (ed.) *Approaches to the Archaeological Heritage.* Cambridge: Cambridge University Press, 125-31.

Cleere, H.F. (ed.) (1989a) *Archaeological Heritage Management in the Modern World.* London: Unwin Hyman.

Cleere, H.F. (ed.) (1989b) 'Introduction: the rationale of archaeological heritage management' in Cleere, H.F. (ed.). *Archaeological Heri-*

tage Management in the Modern World. London: Unwin Hyman, 1-19.

Cole, D.H. (2002) *Pollution and Property: comparing ownership institutions for environmental protection*. Cambridge: Cambridge University Press.

Cook, B.F. (1991) 'The archaeologist and the art market: policies and practice', *Antiquity* 65, 533-7.

Crosby, A. (2002) 'Archaeology and *vanua* development in Fiji', *World Archaeology* 34.2, 363-78.

Crowther, D. (1989) 'Archaeology, material culture and museums', in Pearce, S.M. (ed.) *Museum Studies in Material Culture*. Leicester: Leicester University Press, 35-46.

Dahlman, C.J. (1980) *The Open-Field System and Beyond: property rights analysis of an economic institution*. Cambridge: Cambridge University Press.

Darvill, T. (1987) *Ancient Monuments in the Countryside: an archaeological management review*. English Heritage Archaeological Report 5. London: English Heritage.

Darvill, T. (1993) *Valuing Britain's Archaeological Resource*. Bournemouth University Inaugural Lecture. Bournemouth: Bournemouth University.

Darvill, T. (1995) 'Value systems in archaeology', in Cooper, M.A., Firth, A., Carman, J. and Wheatley, D. (eds) *Managing Archaeology*. London: Routledge, 40-50.

Darvill, T. 2005. ' "Sorted for ease and whiz"? Approaching value and importance in archaeological resource management', in Mathers, C., Darvill, T. and Little, B.J. (eds) *Heritage of Value, Archaeology of Renown: reshaping archaeological assessment and significance*. Gainesville: University Press of Florida, 21-42.

Darvill, T., Saunders, A. and Startin, B. (1987) 'A question of national importance: approaches to the evaluation of ancient monuments for the Monuments Protection Programme in England', *Antiquity* 61, 393-408.

Department of National Heritage (1997) *Treasure Act 1996 Code of Practice*. London: HMSO.

Ditchfield, R. (2000) *Intellectual Property Rights, Trade and Biodiversity: seeds and plant varieties*. London: IUCN and Earthscan Publications.

Douglas, M. and Isherwood, B. (1979) *The World of Goods: towards an anthropology of consumption*. London: Allen Lane.

Eggertsson, T. (1990) *Economic Behaviour and Institutions*. Cam-

bridge Surveys of Economic Literature. Cambridge: University Press.

Evans, J.G. (1975) *The Environment of Early Man in the British Isles.* London: Paul Elek.

Faulkner, N. (2000) 'Archaeology from below', *Public Archaeology* 1.1, 21-33.

Field, B. (1989) 'The evolution of property rights', *Kyklos* 42, 319-45.

Field, J., Barker, J., Barker, R., Coffey, E., Coffey, L., Crawford, E., Darcy, L., Fields, T., Lord, G., Steadman, B. and Colley, S. (2000) ' "Coming back": Aborigines and archaeologists at Cuddie Springs', *Public Archaeology* 1.1, 35-48.

Foucault, M. (1977) *Discipline and Punish: the birth of the prison.* French edition 1975 entitled *Surveiller et punir: naissance de la prison.* Trans. A. Sheridan. London: Allen Lane.

Fowler, D.D. (1984) 'Ethics in contract archaeology', in Green, E.L. (ed.) *Ethics and Values in Archaeology.* New York: Free Press, 108-16.

Fox, R.G. and King, B.J. (eds) (2002) *Anthropology beyond Culture.* Oxford: Berg.

Funari, P.P.A. (2004) 'Public archaeology in Brazil', in Merriman, N. (ed.) *Public Archaeology.* London: Routledge, 202-10.

Gamble, C. (1993a) 'Ancestors and agendas', in Yoffee, N. and Sherratt, A. (eds) *Archaeological Theory: who sets the agenda?* New Directions in Archaeology. Cambridge: Cambridge University Press, 39-52.

Gamble, C. (1993b) *Timewalkers: the prehistory of global colonization.* New York: John Wiley.

Gavison, R. (1983) 'Information control: availability and exclusion', in Benn, S.I. and Gaus, G.F. (eds) *Public and Private in Social Life.* London: Croom Helm, 113-34.

Giddens, A. (1984) *The Constitution of Society: outline of the theory of structuration.* Cambridge: Polity Press.

Gilpin, A. (1995) *Environmental Impact Assessment: cutting edge for the twenty-first century.* Cambridge: Cambridge University Press.

Godelier, M. (1986) *The Mental and the Material.* London: Verso.

Godwin, W. (1971 [1799]) *Enquiry Concerning Political Justice.* Abridged and edited by K.C. Carter. Oxford: Clarendon.

Goldstein, J.H. (1990) 'The prospects for using market incentives for conservation of biological diversity', in Orians, G.H., Kunin, W.E. and Swierzbinski, J.E. (eds) *The Preservation and Valuation of*

Bibliography

Biological Resources. Seattle and London: University of Washington Press, 246-81.

Graham, R. (1989) 'The role of contract in anarchist ideology', in Goodway, D. (ed.) *For Anarchism: history, theory and practice.* History Workshop Series. London: Routledge, 150-75.

Greenfield, J. (1989) *The Return of Cultural Treasures.* Cambridge: Cambridge University Press.

Hann, C. (ed.) (1998) *Property Relations: renewing the anthropological tradition.* Cambridge: Cambridge University Press.

Harrison, S. (1992) 'Ritual as intellectual property', *Man* 27.2, 225-44.

Helly, D.O. and Reverby, S.M. (eds) (1992) *Gendered Domains: rethinking public and private in women's history: essays from the Seventh Berkshire Conference on the History of Women.* Ithaca, NY: Cornell University Press.

Herzfeld, M. (1997) *Cultural Intimacy: social poetics in the nation state.* London: Routledge.

Hodder, I., Shanks, M., Alexandri, A., Buchli, V., Carman, J., Last, J. and Lucas, G. (eds) (1995) *Interpreting Archaeology: finding meaning in the past.* London: Routledge.

Hone, P. (1997) 'The financial value of cultural, heritage and scientific collections: a public management necessity', *Australian Accounting Review* 7.1, 38-43.

Hyde, L. (1983) *The Gift: imagination and the erotic life of property.* New York: Random House.

Hutton, W. (1999) *The Stakeholder Society: writings on politics and economics.* Edited by D. Goldblatt. Cambridge: Polity Press.

Isler-Kerényi, C. (1994) 'Are collectors the real looters?', *Antiquity* 68, 350-2.

Johnson, M. (1993) *Housing Culture: traditional architecture in an English landscape.* London: UCL Press.

Johnson, P. and Thomas, B. (1991) 'Museums: an economic perspective', in Pearce, S. (ed.) *Museum Economics and the Community.* New Research in Museum Studies: an international series 2. London: The Athlone Press, 5-40.

Johnston, C. (1994) *What is Social Value? A discussion paper.* Australian Heritage Commission Technical Publication 3. Canberra: Australian Government Publishing Services.

Jones, S. (2004) *Early Medieval Sculpture and the Production of Meaning, Value and Place: the case of Hilton of Cadboll.* Edinburgh: Historic Scotland.

Kopytoff, I. (1986) 'The cultural biography of things: commoditization

as process', in Appadurai, A. (ed.) *The Social Life of Things: commodities in cultural perspective*. Cambridge: Cambridge University Press.

Kropotkin, P. (1970) *Kropotkin's Revolutionary Pamphlets: a collection of writings by Peter Kropotkin*. Edited by R.N. Baldwin. New York: Dover.

Kropotkin, P. (1972a) *The Conquest of Bread*. London: Allen Lane.

Kropotkin, P. (1972b) *Mutual Aid: a factor of evolution*. London: Allen Lane.

Kropotkin, P. (1974) *Fields, Factories and Workshops Tomorrow*. London: George Allen and Unwin.

Kuper, A. (1999) *Culture: the anthropologists' account*. Cambridge: Harvard University Press.

Layton, R. (ed.) (1989a) *Conflict in the Archaeology of Living Traditions*. London: Routledge.

Layton, R. (ed.) (1989b) *Who Needs the Past? Indigenous values and archaeology*. London: Routledge.

Lipe, W.D. (1984) 'Value and meaning in cultural resources', in Cleere, H.F. (ed.) *Approaches to the Archaeological Heritage*. Cambridge: Cambridge University Press, 1-11.

Lowenthal, D. (1996) *The Heritage Crusade and the Spoils of History*. London: Viking.

Luff, R. and Rowley-Conwy, P. (1994a) 'The (dis)integration of environmental archaeology', in Luff, R. and Rowley-Conwy, P. (eds) *Whither Environmental Archaeology?* Oxbow Monograph 38. Oxford: Oxbow, 1-3.

Luff, R. and Rowley-Conwy, P. (eds) (1994b) *Whither Environmental Archaeology?* Oxbow Monograph 38. Oxford: Oxbow.

Malatesta, E. (1977) *Errico Malatesta: his life and ideas*. Edited by V. Richards. London: Freedom Press.

Mapunda, B. and Lane, P. (2004) 'Archaeology for whose interest – archaeologists or the locals?' in Merriman, N. (ed.) *Public Archaeology*. London: Routledge, 211-23.

Marshall, Y. (2002) 'What is community archaeology?', *World Archaeology* 34.2, 211-19.

Marx, K. (1949) *Capital: a critical analysis of capitalist production*. Trans. S. Moore and E. Aveling. London: George Allen and Unwin.

Mathers, C., Darvill, T. and Little, B.J. (eds) (2005) *Heritage of Value, Archaeology of Renown: reshaping archaeological assessment and significance*. Gainesville: University Press of Florida.

Mauss, M. (1990) *The Gift: the form and reason for exchange in archaic*

societies. Translated from French by W.D. Halls. London: Routledge.

McDavid, C. (1997) 'Descendants, decisions and power: the public interpretation of archaeology of the Levi Jordan Plantation', in McDavid, C. and Babson, D. (eds) *In the Realm of Politics: prospects for public participation in African-American archaeology.* California: Society for Historical Archaeology (= *Historical Archaeology* 31.3), 114-31.

McDavid, C. (1999) 'From real space to cyberspace: contemporary conversations about the archaeology of slavery and tenancy', *Internet Archaeology* 6
http://intarch.ac.uk/journal/issue6/mcdavid_toc.html.

McDavid, C. (2000) 'Archaeology as cultural critique: pragmatism and the archaeology of a southern United States plantation', in Holtorf, C. and Karlsson, H. (eds) *Philosophy and Archaeological Practice: perspectives for the 21st century.* Göteborg: Bricoleur Press, 221-39.

McDavid, C. (2002) 'Archaeology that hurts; descendants that matter: a pragmatic approach to collaboration in the public interpretation of African-American archaeology', *World Archaeology* 34.2, 303-14.

McDavid, C. (2004) 'Towards a more democratic archaeology? The Internet and public archaeological practice', in Merriman, N. (ed.) *Public Archaeology.* London, Routledge, 159-87.

McDavid, C. and Babson, D. (eds) (1997) *In the Realm of Politics: prospects for public participation in African-American archaeology.* California: Society for Historical Archaeology (= *Historical Archaeology* 31.3).

McGimsey, C.R. (1972) *Public Archaeology.* New York: Seminar Books.

McGimsey, C.R. (1984) 'The value of archaeology', in Green, E.L. (ed.) *Ethics and Values in Archaeology.* New York: Free Press, 171-4.

McKean, M. (1992) 'Management of traditional common lands (*Iriachi*) in Japan', in Bromley, D.W. (ed.) *Making the Commons Work.* San Francisco: Institute for Contemporary Studies, 63-98.

McManamon, F.P. (1991) 'The many publics for archaeology', *American Antiquity* 56, 121-30.

Mehrabian. A. (1976) *Public Places and Private Spaces: the psychology of work, play and living environments.* New York: Basic Books.

Merriman, N. (1991) *Beyond the Glass Case: the public, museums and heritage in Britain.* London: Leicester University Press.

Merriman, N. (ed.) (2004) *Public Archaeology.* London: Routledge.

Merryman, J. (1989) 'The public interest in cultural property', *California Law Review* 77.2, 339-64.

Merryman, J. (1994) 'A licit traffic in cultural objects', *Vth Symposium on 'Legal Aspects of International Trade in Art'*, Vienna, 28-30 September 1994.

Messenger, P.M. (ed.) (1999) *The Ethics of Collecting Cultural Property*. Albuquerque: University of New Mexico Press.

Micallef, F. and Peirson, G. (199) 'Financial reporting of cultural, heritage, scientific and community collections', *Australian Accounting Review* 7.1, 31-50.

Montagu, A. 1976. *The Nature of Human Aggression*. Oxford: Oxford University Press.

Moser, S., Glazier, D., Phillips, J.E., Nasr el Namr. L., Mouier, M.S., Aiesh, R.N., Richardson, S., Conner, A., and Seymour, M. (2002) 'Transforming archaeology through practice: strategies for collaborative archaeology and the community archaeology project at Quesir, Egypt', *World Archaeology* 34.2, 220-48.

Nicklin, K. (1990) 'The Epic of the Ekpu: ancestor figures of Oron, South-East Nigeria', in Gathercole, P. and Lowenthal, D. (eds) *The Politics of the Past*. London: Unwin Hyman.

Olwig, K.R. (1989) 'Nature interpretation: a threat to the countryside', in Uzzell, D. (ed.) *Heritage Interpretation*, vol. 1: *The Natural and Built Environment*. London: Bellhaven, 132-41.

O'Keefe, P.J. and Prott, L.V. (1984) *Law and the Cultural Heritage*, vol. 1: *Discovery and Excavation*. Abingdon: Professional Books.

O'Keefe, P.J. and Prott, L.V. (1992) ' "Cultural heritage" or "cultural property"?', *International Journal of Cultural Property* 1, 307-19.

O'Keefe, P.J. (1997) *Trade in Antiquities: reducing destruction and theft*. London: Archetype and UNESCO.

O'Neill, J. (1993) *Ecology. Policy and Politics: human well-being and the natural world*. Environmental Philosophies. London: Routledge.

Ordeshook, P.C. (1986) *Game Theory and Political Theory: an introduction*. Cambridge: Cambridge University Press.

Orians, G.H., Kunin, W.E., and Swierzbinski, J.E. (eds) (1990) *The Preservation and Valuation of Biological Resources*. Seattle and London: University of Washington Press.

Ostrom, E. (1990) *Governing the Commons: the evolution of institutions for collective action*. Cambridge: Cambridge University Press.

Palmer, N. (1992) 'Editorial', *International Journal of Cultural Property* 1.1, 5-7.

Parker Pearson, M. and Ramilisonina (2004) 'Public archaeology and indigenous communities', in Merriman, N. (ed.) *Public Archaeology*. London: Routledge, 224-39.

Pearce, S.M. (1995) *On Collecting: an investigation into collecting in the European tradition*. Collecting Cultures. London: Routledge.

Popular Memory Group (1982) 'Popular memory: theory, politics, method', in Centre for Contemporary Cultural Studies, *Making Histories: studies in history-writing and politics*. London: Hutchinson, 205-52.

Power, M. (1997) 'Introduction: from the science of accounts to the accountability of science', in Power, M. (ed.) *Accounting and Science: natural enquiry and commercial reason*. Cambridge: Cambridge University Press, 1-35.

Qin, D. (2004) 'The effects of the antiquities market on archaeological development in China', in Merriman, N. (ed.) *Public Archaeology*. London: Routledge, 292-9.

Quinn, M. (1994) *The Swastika: constructing the symbol*. London: Routledge.

Renfrew, C. (1993) 'Collectors are the real looters', *Archaeology* 16.

Renfrew, C. (1995) 'Art fraud: raiders of the lost past', *Journal of Financial Crime* 3.1, 7-9.

Renfrew, C. (2000) *Loot, Legitimacy and Ownership*. London: Duckworth.

Roberts, N. (1989) *The Holocene: an environmental history*. Oxford: Blackwell.

Rowlands, M. (2004) 'Cultural rights and wrongs: uses of the concept of property', in Verdery, K. and Humphrey, C. (eds) *Property in Question: value transformations in the global economy*. Wenner-Gren International Symposia Series. Oxford: Berg, 207-26.

Ryan, A. (1983) 'Public and private property', in Benn, S.I. and Gaus, G.F. (eds) *Public and Private in Social Life*. London: Croom Helm, 223-45.

Ryan, A. (1984) *Property and Political Theory*. Oxford: Blackwell.

Sassoon, A.S. (1987) *Women and the State: the shifting boundaries of public and private*. London: Unwin Hyman.

Schadla-Hall, T. (2004) 'The comforts of unreason: the importance and relevance of alternative archaeology', in Merriman, N. (ed.) *Public Archaeology*. London: Routledge, 255-71.

Schwarz, M. and Thompson, M. (1990) *Divided We Stand: redefining politics, technology and social choice*. Hemel Hempstead: Harvester Wheatsheaf.

Shackley, M. (1981) *Environmental Archaeology*. London: George Allen and Unwin.

Shackley, M. (1985) *Using Environmental Archaeology*. London: Batsford.

Simmonds, I.G. (1993) *Interpreting Nature: cultural constructions of the environment*. London: Routledge.

Sinden, J.A. and Worrell, A.C. (1979) *Unpriced Values: decisions without market prices*. New York: John Wiley and Sons.

Skeates, R. (2000) *Debating the Archaeological Heritage*. London: Duckworth.

Smith, C. (1989) *Auctions: the social construction of value*. Hemel Hempstead: Harvester Wheatsheaf.

Smith, L. (2004) *Archaeological Theory and the Politics of Cultural Heritage*. London: Routledge.

Swanson, J.A. (1992) *The Public and the Private in Aristotle's Political Philosophy*. Ithaca, NY and London: Cornell University Press.

Thoden van Velzen, D. (1996) 'The world of Tuscan tomb robbers: living with the local community and the ancestors', *International Journal of Cultural Property* 5.1, 111-26.

Thomas, R.M. (2004) 'Archaeology and authority in England', in Merriman, N. (ed.) *Public Archaeology*. London, Routledge, 191-201.

Thomson, J. (1977 [1877]) *Public and Private Life of Animals*. London: Paddington Press.

Thompson B.H. (2000) 'Tragically difficult: the obstacles to governing the commons', *Environmental Law* 30, 241-78.

Thompson, M. (1979) *Rubbish Theory: the creation and destruction of value*. Oxford: Clarendon.

Turkel, G. (1992) *Dividing Public and Private: law, politics, and social theory*. Westport: Praeger.

Verdery, K. and Humphrey, C. (eds) (2004) *Property in Question: value transformations in the global economy*. Wenner-Gren International Symposium Series. Oxford: Berg.

Wade, R. (1987) 'The management of common property resources: collective action as an alternative to privatisation or state regulation', *Cambridge Journal of Economics* 11, 95-106.

Walsh, K. (1992) *The Representation of the Past: museums and heritage in the post-modern world*. The Heritage: Care, Preservation, Management. London: Routledge.

Warren, K.J. (1989) 'A philosophical perspective on the ethics and resolution of cultural property issues', in Messenger, P. (ed.) *The*

Ethics of Collecting Cultural Property. Albuquerque: University of New Mexico Press, 1-26.

Way, T. (1997) 'The victim or the crime: park focussed conflict in Cambridgeshire and Huntingdonshire 1200', in Carman, J. (ed.) *Material Harm: archaeological studies of war and violence.* Glasgow: Cruithne Press, 143-66.

Wenban-Smith, F. (1995) 'Square pegs in round holes: problems in managing the Palaeolithic heritage', in Cooper, M.A., Firth, A., Carman, J. and Wheatley, D. (eds) *Managing Archaeology.* TAG. London: Routledge.

Weiner, A.B. (1992) *Inalienable Possessions: the paradox of keeping-while-giving.* Berkeley: University of California Press.

Wilson, P.J. (1988) *The Domestication of the Human Species.* New Haven and London: Yale University Press.

Woodcock, G. (1975) *Anarchism: a history of libertarian ideas and movements.* London: Pelican.

Woodcock, G. (ed.) (1977) *The Anarchist Reader.* London: Fontana.

World Archaeological Bulletin 6 (1992) *Special issue on the Reburial Issue.* Southampton: World Archaeological Congress.

World Archaeology 34.2 (2002) *Community Archaeology.*

Wright, P. (1985) *On Living in an Old Country.* London: Verso.

Young, M.D. (1992) *Sustainable Investment and Resource Use: equity, environmental integrity and economic efficiency.* Paris: UNESCO.

Index

Index

Index